The
Lightroom
Mobile

How to extend the
power of what you
do in Lightroom to
your mobile devices

Book

Scott Kelby

Author of the top-selling digital photography
book ever—*The Digital Photography Book*, part 1

The Lightroom Mobile Book

The Lightroom Mobile Book **Team**

MANAGING EDITOR
Kim Doty

COPY EDITOR
Cindy Snyder

ART DIRECTOR
Jessica Maldonado

PHOTOGRAPHY
Scott Kelby

PUBLISHED BY

Peachpit Press

Composed in Myriad Pro (Adobe Systems Incorporated) by Kelby Media Group Inc.

Trademarks
All terms mentioned in this book that are known to be trademarks or service marks have been appropriately capitalized. Peachpit Press cannot attest to the accuracy of this information. Use of a term in the book should not be regarded as affecting the validity of any trademark or service mark.

Photoshop and Lightroom are registered trademarks of Adobe Systems Incorporated.
iPhone and iPad are registered trademarks of Apple Inc.
Android is a registered trademark of Google Inc.

Warning and Disclaimer
This book is designed to provide information about Adobe Lightroom Mobile. Every effort has been made to make this book as complete and as accurate as possible, but no warranty of fitness is implied.

The information is provided on an as-is basis. The author and Peachpit Press shall have neither the liability nor responsibility to any person or entity with respect to any loss or damages arising from the information contained in this book or from the use of the discs, videos, or programs that may accompany it.

THIS PRODUCT IS NOT ENDORSED OR SPONSORED BY ADOBE SYSTEMS INCORPORATED, PUBLISHER OF ADOBE PHOTOSHOP AND PHOTOSHOP LIGHTROOM.

ISBN 13: 978-0-134-54725-1

ISBN 10: 0-134-54725-X

1 16

Printed and bound in the United States of America

www.peachpit.com
www.kelbyone.com

*This book is dedicated
to my dear friend,
and colleague
Dave Clayton.
One of the best guys
on the planet.*

Acknowledgments

Although only one name appears on the spine of this book, it takes a team of dedicated and talented people to pull a project like this together. I'm not only delighted to be working with them, but I also get the honor and privilege of thanking them here.

To my amazing wife Kalebra: I don't know how you do it, but each year you somehow get more beautiful, more compassionate, more generous, more fun, and you get me to fall even more madly in love with you than the year before (and so far, you've done this 27 years in a row)! They don't make words to express how I feel about you, and how thankful and blessed I am to have you as my wife, but since all I have here are words—thank you for making me the luckiest man in the world.

To my wonderful, crazy, fun-filled, son Jordan: In some of my earlier books, I wrote that you were the coolest little boy any dad could ever ask for. Now that you're off at college, you're not a little boy by any means, but you are definitely still the coolest! Although I know you don't read these acknowledgments, it means so much to me that I can write it, just to tell you how proud I am of you, how thrilled I am to be your dad, and what a great big brother you've become to your little sister. Your mom and I were truly blessed the day you were born (and we sure miss you back here at home).

To my beautiful daughter Kira: You are a little clone of your mom, and that's the best compliment I could ever give you. You have your mom's sweet nature, her beautiful smile, and like her, you always have a song in your heart. You're already starting to realize that your mom is someone incredibly special, and take it from Dad, you're in for a really fun, exciting, hug-filled, and adventure-filled life. I'm so proud to be your dad.

To my big brother Jeff: A lot of younger brothers look up to their older brother because, well… they're older. But I look up to you because you've been much more than a brother to me. It's like you've been my "other dad" in the way you always looked out for me, gave me wise and thoughtful council, and always put me first—just like Dad put us first. Your boundless generosity, kindness, positive attitude, and humility have been an inspiration to me my entire life, and I'm just so honored to be your brother and lifelong friend.

To my in-house team at KelbyOne: You make coming into work an awful lot of fun for me, and each time I walk in the door, I can feel that infectious buzz of creativity you put out that makes me enjoy what we do so much. I'm still amazed to this day at how we all come together to hit our often impossible deadlines, and as always, you do it with class, poise, and a can-do attitude that is truly inspiring. You guys rock!

To Erik Kuna: For taking the weight of the world on your back, so it didn't crush mine, and for working so hard to make sure we do the right thing, the right way.

To my Editor Kim Doty: I couldn't be any luckier than to have you editing my books and shepherding them along. This one has taken a lot more time and sweat than any of us expected, but you always kept your trademark attitude and a smile on your face. Both of those kept a smile on mine, and I'm very grateful.

To Jessica Maldonado: I can't thank you enough for all your hard work on the cover, layout, and on the look of this and all my books. I love the way you design, and all the clever little things you add to everything you do. You're incredibly talented, a joy to work with, and I feel very, very fortunate to have you on my team.

To Nancy Davis: My editor at Peachpit Press. Thanks for picking up so well where our other Nancy left off. It's so much fun getting to work with you.

To my dear friend and business partner Jean A. Kendra: Thanks for putting up with me all these years, and for your support for all my crazy ideas. It really means a lot.

To my Executive Assistant Lynn Miller: Thanks so much for managing my schedule and constantly juggling it so I can actually have time to write. I know I don't make it easy (I'm kind of a moving target), but I really appreciate all your hard work, wrangling, and patience throughout it all. I'm very glad to have you on our team.

To all the talented and gifted photographers who have taught me so much over the years: Moose Peterson, Joe McNally, Bill Fortney, George Lepp, Anne Cahill, Vincent Versace, David Ziser, Jim DiVitale, Tim Wallace, Peter Hurley, Cliff Mautner, Dave Black, Helene Glassman, and Monte Zucker.

To my mentors John Graden, Jack Lee, Dave Gales, Judy Farmer, and Douglas Poole: Your wisdom and whip-cracking have helped me immeasurably throughout my life, and I will always be in your debt, and grateful for your friendship and guidance.

Most importantly, I want to thank God, and His Son Jesus Christ, for leading me to the woman of my dreams, for blessing us with such amazing children, for allowing me to make a living doing something I truly love, for always being there when I need Him, for blessing me with a wonderful, fulfilling, and happy life, and such a warm, loving family to share it with.

Other Books by Scott Kelby

The Adobe Photoshop Lightroom Book for Digital Photographers

How Do I Do That in Lightroom?

How Do I Do That in Photoshop?

Professional Portrait Retouching Techniques for Photographers Using Photoshop

The Digital Photography Book series

Light It, Shoot It, Retouch It: Learn Step by Step How to Go from Empty Studio to Finished Image

The Adobe Photoshop Book for Digital Photographers

The Photoshop Elements Book for Digital Photographers

It's a Jesus Thing: The Book for Wanna Be-lievers

Photoshop for Lightroom Users

Professional Sports Photography Workflow

About the Author

Scott Kelby

Scott is Editor, Publisher, and co-founder of *Photoshop User* magazine, and co-host of the influential weekly photography talk show, *The Grid*. He is President of KelbyOne, the online education community for creative people.

Scott is a photographer, designer, and award-winning author of more than 80 books, including *The Adobe Photoshop Lightroom Book for Digital Photographers, Professional Portrait Retouching Techniques for Photographers Using Photoshop, How Do I Do That in Lightroom?, Light It, Shoot It, Retouch It: Learn Step by Step How to Go from Empty Studio to Finished Image,* and *The Digital Photography Book* series. The first book in this series, *The Digital Photography Book*, part 1, has become the top-selling book on digital photography in history.

For six years straight, Scott has been honored with the distinction of being the world's #1 best-selling author of photography technique books. His books have been translated into dozens of different languages, including Chinese, Russian, Spanish, Korean, Polish, Taiwanese, French, German, Italian, Japanese, Dutch, Swedish, Turkish, and Portuguese, among others.

Scott is Training Director for the Adobe Photoshop Seminar Tour and Conference Technical Chair for the Photoshop World Conference. He's featured in a series of online courses, from KelbyOne.com, and has been training photographers and Adobe Photoshop users since 1993.

For more information on Scott, visit:

His daily blog at scottkelby.com

Twitter: **@scottkelby**

Instagram: **@scottkelby**

Facebook: **facebook.com/skelby**

Google+: **scottgplus.com**

Seven Things You've Got to Know Right Now!

(1) The reason you have to know these right now is…if you turn the page without reading this, you will not only be totally and hopelessly lost, you actually may damage your hard drive. Okay, none of that is true, but there are tricks we authors have to employ to get our readers (faithful folks like you, who have either invested in this book, or at the very least shoplifted it, and there's certainly some risk in that) to read this stuff you want to just skip over, but we write these intros for a reason: we're paid by the page. No! That's not it at all (though, I wish it was). We're paid to make books that work for the reader, and if you read this stuff, it will help you get more out of the book, and that's important to all of us. Well, some of us, but really, who's counting?

(2) Read this book in order if you're new to Lightroom Mobile. I know this is different than some of my other books, but for this particular one, it helps if you read it in the order it's presented here. I promise it will help, and you'll be able to follow right along with everything.

(3) If you're a "grumpy-pants old guy," skip the chapter intros entirely. Writing these quirky chapter intro pages, which have little or nothing to do with what's actually in the book, is a long-standing tradition of mine, and somehow lots of folks absolutely love them (I even published an entire book of nothing but chapter intros—I am not making this up), but some serious-type folks hate them with a passion of a thousand burning suns. So, if you're one of "those" folks, do yourself a favor and just skip them. And, if you're even the least bit agitated by reading this intro here, absolutely, positively skip them. This is tame. The rest of the book, however, is just straightforward techniques.

The Rest Are over Here, so Don't Skip This.

(4) I have good news: If you've used Lightroom on your desktop, and you're even relatively familiar with how it works, learning Lightroom Mobile is going to be easy for you. It has many of the same features already in Lightroom on your desktop—it's just that Lightroom Mobile has an entirely different interface (I've joked with Adobe that they just built a mobile-editing application, and then, at the last minute, decided to call it Lightroom Mobile. They did not find that funny). This whole book is about teaching you the workflow, so this will be pretty easy for you.

(5) I created a special video just for you! As a special learning bonus, I created a video just for readers of this book, where I take you through my own Lightroom Mobile workflow, from start to finish. You'll see exactly how I use it in my own work to help you learn how to make it work for you. You can find it here: **http: //kelbyone.com/books/lrmobile**.

(6) Lightroom Mobile is a little different, depending on where you use it. The size of the screen on a phone, versus a tablet, is much different, which is why sometimes the experience changes between devices. For example, on a tablet, you'll see five icons across the bottom when you tap on a photo. The first one, Filmstrip, lets you display your thumbnails across the bottom of the screen to make navigating to images easier. On a phone, there's not room for the Filmstrip, so there are only four icons. It's stuff like that. It doesn't happen a whole bunch, but it happens.

(7) Lightroom Mobile is a little different on Apple's iOS than it is on Android devices. For example, although the features are now finally (finally!) pretty much identical, some of the names are different. For example, on an iPhone, images are imported from your Camera Roll; on an Android device, they come in from your Gallery. If I write that out each time, it gets really tedious for you, so I just use "Camera Roll," but now you know what I mean. Luckily, the differences like this are very few, but I did mention when something is not available for a particular OS.

Contents

CHAPTER FIVE

Cropping and Stuff Like Cropping

Hey, Rotating Is Like Cropping, Right?

CHAPTER SIX

Sharing Your Images

How to Share Your Work with the World (or Just Your Sister. It's Your Call)

CHAPTER SEVEN

Sharing Your Shoot Live

Yes, You Can Share Your Shoot Live with Anyone, Anywhere, Anytime

CHAPTER EIGHT **115**

Using the Built-In Camera

It's Way Better Than You'd Think

CHAPTER NINE **125**

All the Other Stuff

This Stuff Needs a Home, Too

SHUTTER SPEED: 1/6 sec | F-STOP: ƒ/4 | ISO: 4000 | FOCAL LENGTH: 11mm | LOCATION: The Cow Restaurant, Queenstown, New Zealand

Chapter One

Getting Your Images Into Lightroom Mobile

Ya Gotta Start Somewhere, So Well...
Here's Where Ya Do

Before we get started, it's probably helpful to know that there are actually multiple segments to the whole Lightroom experience that are all designed to extend the power of Lightroom. For example, there's Lightroom Desktop, which is the version of Lightroom that lives on your laptop or your desktop computer. And, of course, there's Lightroom Mobile, which lives on your phone or tablet. Then, there's Lightroom Web (that ties into Lightroom Mobile), which lives in a web browser, and there's Lightroom for Apple TV, which lives on an Apple TV device. But, Adobe has also just released (as of the publishing of this book) Lightroom Foley, which lives in a van down by the river; Lightroom Grandmother, which lives in a cottage in the woods; and Lightroom SpongeBob, which lives in a pineapple under the sea. Now, if it seems that things took an unexpected turn in that last sentence, it's probably because you skipped the intro to this book, where I warned you about these chapter intros and how they are simply here as a mental break, a pause from all the nonstop techniques, giving you, the reader, an opportunity to gather your thoughts and put them in a small basket to take to grandma's house.

Download and Sign In to Lightroom Mobile

Download the Lightroom app (it's free) onto your iPad, iPhone, or Android device. When you launch it, it's going to ask you to sign in with your Adobe ID and password (this is how it knows Lightroom on your computer and Lightroom on your mobile device are linked to each other). If you don't have an Adobe ID yet (it's just a simple user account), you can sign up for one (it's free) by clicking on the Get an Adobe ID link below the Sign In button. It takes you to another window where you can create your account (no credit card info; just your name, address, and stuff like that).

Choose Your Options

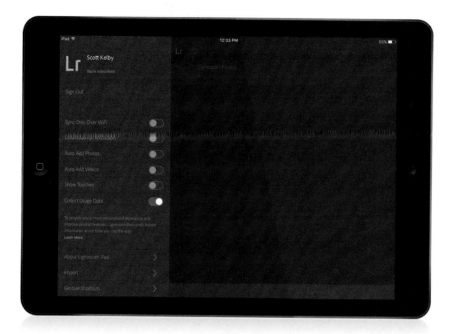

At this point, you haven't imported any photos. We haven't chosen which collections to sync with Lightroom Mobile, so there's nothing there yet (but there will be soon). But, first, let's look at where your options and preferences are located. (*Note:* Some of the options shown here are currently only available for iOS devices.) When you launch Lightroom on your mobile device, you'll be in the Collections view and you'll see the little LR logo in the top-left corner of the screen. Tap on it and the Sidebar slides out from the left side with your options, includ-ing whether you want to sync photos just over wireless or whether you're okay with them syncing over cellular, too (which might affect your data plan charges). If you turn on Auto Add Photos or Auto Add Videos, Lightroom Mobile will automatically add photos or videos taken with your phone (or tablet) and sync them with Lightroom on your desktop (we'll look at the Download Full Resolution option in Chapter 9). Turning on Show Touches shows a red "dot" when you tap the screen (helpful when doing a Lightroom demo from your mobile device or teaching someone how to use Lightroom on their mobile device for the first time). Also, as Adobe continues to develop this app, they collect anonymous data to help them see how people are using it. If you'd prefer they didn't collect that data from you, you can turn off Collect Usage Data. The rest are options for help, gesture shortcuts, signing out of your account, and so on (we'll look at a few more of these options later in the book). To hide that Sidebar panel again, just tap on it. Okay, let's get some photos in here!

Sign In to Lightroom on Your Desktop

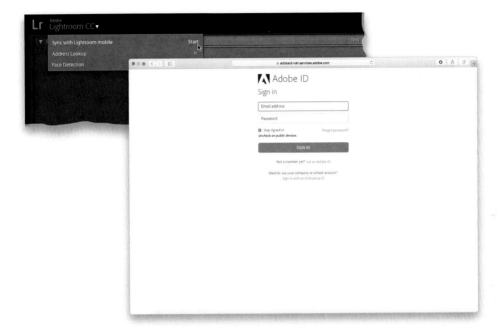

Okay, this may win the international "We hide commands in the most unlikely places" award for Adobe, but if you move your cursor over the Lightroom logo on your desktop (up in the left-hand corner of the window), a little white down-facing triangle appears, indicating that there's something that happens if you click there. So, go ahead and click there and the Activity panel will appear. Now, to the right of Sync with Lightroom Mobile, click Start. Your web browser will open with the Adobe ID Sign In page, where you'll enter your Adobe ID and password, and then click Sign In.

Turn On Sync with Lightroom Mobile

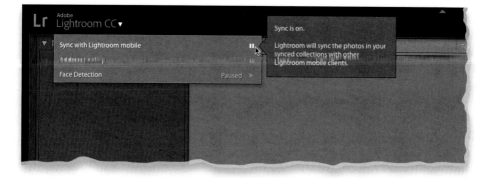

Now, back in the Activity panel, you'll see a control for turning the Sync with Lightroom Mobile feature on/off. Make sure that's turned on (if it's not, just click on it to turn it on), and now you're good to go. Don't worry—turning this sync feature on absolutely does *not* send all your images over to Lightroom Mobile. We'll look at how to choose exactly which image collections you want sent over next, and only those images will go. This is just a starting point (you have to start somewhere, right?), but no images get synced by turning this Sync feature on at this point.

Choosing Which Collections to Sync

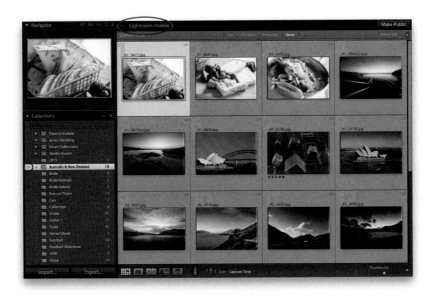

Go to the Collections panel in Lightroom on your desktop, and you'll see a gray box to the left of each collection. We use these boxes to choose which collections get synced over to Lightroom on our mobile device—just click in a box and a little sync icon appears in that box (kind of like a checkmark; shown circled here in red), and that collection is now automatically copied over to Lightroom on your mobile device. If you look in the top left of the thumbnail grid, you'll see the sync icon and "Lightroom mobile" appear (also circled here), and a little sync icon appears in the top-right corner of each thumbnail of a synced image, once again, just letting you know that the images in this collection are synced.

Note: Lightroom on your mobile device only works with collections, not folders. So, if you have a folder you want synced, you have to make it a collection first by clicking on it in the Folders panel and dragging it to the Collections panel. Now, you can sync that collection.

You Can Only Sync One Catalog

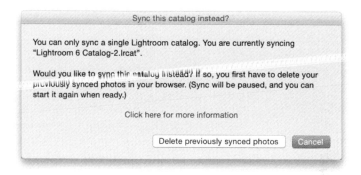

At this point in time (meaning, I figure that at some point in the future this may change, but who knows when or even if), you can only sync one catalog with Lightroom Mobile. That's fine with me, because I'm a one-catalog guy, and I try to convince everybody to try to stick with just one Lightroom catalog because it makes their (your) life easier and less complicated. However, if for some reason you have multiple catalogs, then you'll need to pick which one you want to sync with Lightroom Mobile (again, it doesn't sync your entire catalog—just the collections of images you choose to sync over). If you're a "multi-catalog user" (and you know who you are), and you've chosen a catalog to sync, and then later you decide to sync a different catalog, no sweat. Just open the new catalog you want to sync and turn on Sync with Lightroom Mobile in the Activity panel (see page 5). This will bring up a warning dialog (shown here) letting you know that you've already synced another catalog, and if you choose this one instead, it will replace all the images you synced from the other catalog with any images you choose to send over from this catalog. You'll have the option to choose "Okey Dokey" or cancel and leave the other catalog as your synced catalog.

SHUTTER SPEED: 1/1000 sec | F-STOP: f/8 | ISO: 400 | FOCAL LENGTH: 11mm | LOCATION: Galleries Lafayette, Paris, France

Chapter Two

Working with Collections

They Are the Heart of Lightroom Mobile

If there is one thing that freaks people out about the whole Lightroom Mobile experience, it's that moment when you turn on syncing in Lightroom on your desktop, because you're concerned that once you do, your entire catalog of images on your desktop will be instantly synced over to your phone or tablet. This is a serious concern for you, because you've downloaded so many episodes of *The Bachelor* and *Here Comes Honey Boo Boo* that there's barely any space left on your phone or tablet. So much so that even a single email arriving on your device could cause your phone to spontaneously burst into flames (hey, it happens). Luckily, you can take this worry off your list because turning on Sync with Lightroom Mobile in Lightroom on your desktop doesn't sync all your images. All it does is syncs your nude selfies. That's it. Just those, so you can breathe a sigh of relief. Now, you might be wondering how it knows which are your nude selfies. That's easy—it uses an advanced metadata algorithm (originally developed by NASA for the Space Shuttle Program) that scans each image in your entire library, and then it sends any image it thinks might be a nude selfie (based on percentage of visible flesh tone in the image) to "the cloud," where a handpicked team of Adobe part-time interns briefly views each image onscreen, and anytime they audibly say "ewwwww!" that image is then synced over to Lightroom on your mobile device. I know that must be a tremendous relief to you.

9

Seeing Your Collections
in Lightroom Mobile

Luckily for us, when Lightroom syncs images, it doesn't send the full high-resolution RAW or JPEG photos over to our mobile devices, or we'd run out of storage space pretty quickly. Instead, it sends a smart preview (a compressed version stored in the cloud), which still looks great, and which we can still edit, but at a fraction of the size of the full-resolution image. Okay, let's head over to Lightroom on your mobile device to see if our collections made it over there (I turned on the checkboxes beside 16 collections, as seen above). On my mobile devices, in Collections view (kind of like the homepage), if you look near the top of the screen, you'll see I have 16 Collections and 383 Lightroom Photos. The icons beneath each collection tell you how many unflagged photos are in the collection, as well as how many are flagged as Picks and how many are flagged as Rejects (this is currently only available on a tablet). Unfortunately, you can't (currently) change the size of your collection thumbnails. But, if you tap on Lightroom Photos (near the top left of the screen), not only will you be able to view all your photos in one place, you'll also be able to increase their thumbnail size by pinching-and-zooming (we'll look at this more on page 17).

Creating a New Collection

If you want to create a totally new collection from scratch, in Collections view, tap on the + (plus sign) icon in the top-right corner of the screen. This brings up a dialog where you can name your new collection, as seen here (by default, it names your collection with today's time and date, but you'll probably want to make it something more useful, so tap the little "X" on the far right of the text field to erase that, and then type a new name), then tap OK. It adds a new gray thumbnail to your Collections view screen (as seen here circled on the right; it will appear in your collections based on how you have them sorted. Here, I have them sorted alphabetically, but we'll look at this more later). To access the collection options, tap on the three dots to the right of a collection's name. This brings up a pop-up menu (seen above in the overlay on the right) with all sorts of options, like enabling offline editing (where you can edit images when you don't have Internet access—they'll sync the next time you're connected), renaming your collection, sharing it, or even removing your collection.

Adding Images to a New Collection

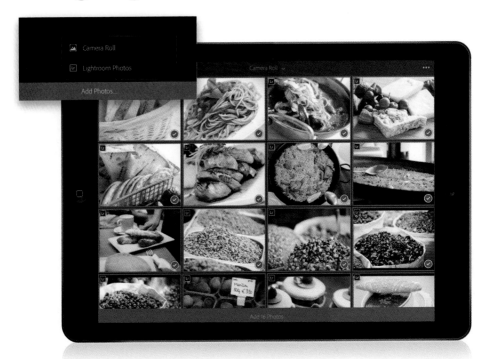

To add images to a new collection, tap on the collection you want to import images to, and it goes to a blank screen. At the bottom you'll see "Add Photos." Tap on that and a pop-up menu appears (seen here in the overlay) asking if you want to import photos from your Camera Roll (or Gallery) on your mobile device, or from your Lightroom Photos. Tap on your choice (if you tap on Camera Roll or Add From Gallery [at the top of the screen], you can use the filter options to find certain photos), then tap on (or tap-and-drag over) the image(s) you want to add to this collection. When you're done, at the bottom of the screen it will say "Add 2 Photos" or "Add 16 Photos," etc. (however many photos you chose). Tap that, and those images will be added to that collection. Now, the next time you go to import images from your Camera Roll, if you see a little Lightroom icon in the top-left corner of an image's thumbnail (as seen here), that's to let you know it has already been added into Lightroom Mobile.

Seeing Your New Collection on Your Desktop

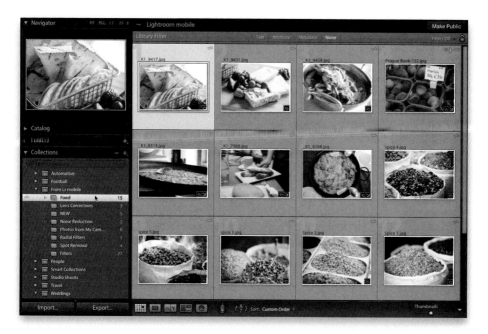

When you create a new collection in Lightroom on your mobile device like we just did, that new collection is synced over to Lightroom on your computer. To help you keep things straight, when this collection appears in your Collections panel, it adds a collection set called, "From Lr mobile," and if you look inside that set, you'll see any collections you've created in Lightroom on your mobile device (as seen here, where our "Food" collection was synced). So, if you've created a bunch of different collections in Lightroom on your mobile device, they all would be listed here. To see only what's in an individual collection, just click on it.

Seeing Where Your Original Images Are Saved

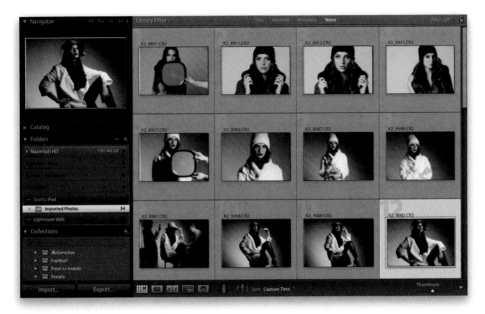

Here's another thing you'll want to know: If you add images that were on your tablet (like these studio shots that were in the Camera Roll of my iPad) to one of your collections, not only does that collection get synced to Lightroom on your computer, but those full-resolution images get copied over, as well. So, you'll be able to see them in the synced collection of course, but if you want to get to the originals for some reason, you'll find them in the Folders panel. In there, you'll see a source with the name of your mobile device (as seen here, where mine's listed as "Scott's iPad"). When I click on that, I see a folder containing the original 34 images copied over from my iPad to my computer. This works the same way with your phone—if you add images taken with your phone's camera to a Lightroom collection, those full-resolution files will be copied back over to Lightroom on your computer. See, you did want to know that now, didn't you? :-)

Choosing How to Sort Your Collections

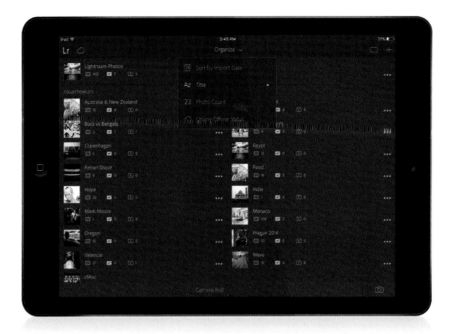

If you tap directly on Organize, at the top of the screen, a pop-up menu appears with sorting options (you can sort the collections by the date you imported them, by their name, by the number of images in each collection, or by their online/offline status). If you tap on any of those sort options, a little white up-facing triangle appears to the right of that option, which lets you choose ascending or descending for your sort order (in other words, if you chose Sort by Import Date, do you want the collection at the top to be the most recently taken photos, or do you want the oldest photos at the top?). Just tap on that arrow to toggle back and forth between the two options.

Seeing Your Images in Grid View

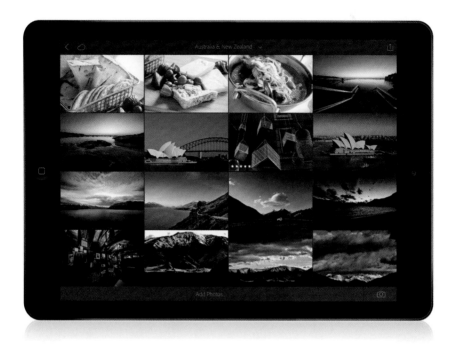

To see the images inside any collection, just tap on a collection and it displays those images in Grid view (as seen here). To scroll through all the images in the collection, just swipe up or down. By the way, if you have one of the latest Apple iPhones (one that supports Apple's 3D Touch and its Peek & Pop feature), when you're scrolling through a collection (or through your Camera Roll when adding images), you can see a larger preview of an image by just tapping-and-holding on the image (if you swipe up when looking at the preview, you also get the options to Share or Remove the image. More on sharing later in Chapter 6, though).

Changing the Size of Your Thumbnails

To change the size of your image thumbnails when you're inside a collection (or in your Camera Roll or Gallery or in your Lightroom Photos), just use the classic "two-finger pinch" to zoom in to larger-sized thumbnails (touching both fingers to the screen and separating them), or zoom out to smaller-sized thumbnails by pinching your two fingers together onscreen. Each time you do either, it zooms to the next larger (or smaller) size.

Choosing Grid View Options

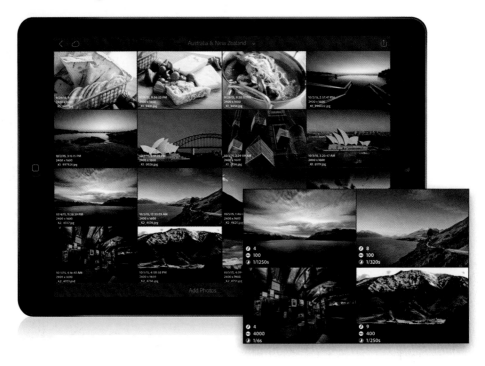

When you're in Grid view, if you tap with *two* fingers, it'll show you the time and date the image was taken, the pixel dimensions, and the filename (as seen here). The second time you two-finger tap, it'll show you some EXIF camera data (the f-stop, ISO, and shutter speed, as seen in the overlay here). The third time you two-finger tap, it shows you badges to let you know if there are any flags, stars, or edits applied to your images (kind of like the way Lightroom on your computer does in its Grid view). And, a fourth two-finger tap will show you if the images have any comments or likes (if you made them Public). A final two-finger tap will hide all the info.

Choosing Your Image Sorting Options

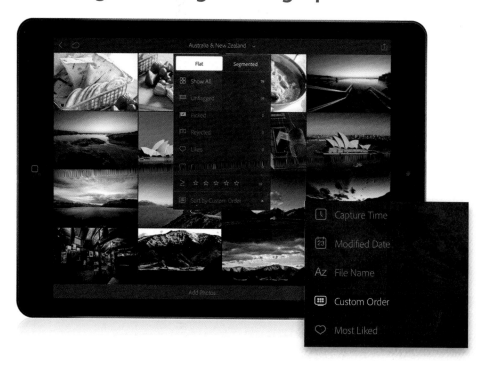

When you're looking at a collection in Grid view, if you tap on the name of the collection at the top of the screen, you'll get a pop-up menu with a bunch of filtering choices (which we're going to talk about in just a bit). For now, look at the last option at the bottom of that menu's Flat options (mine say, "Sort by Custom Order" here, but yours will show whatever you have selected in Lightroom on your computer). If you tap on that sort option, it brings up another pop-up menu (seen here in the overlay), where you can choose the sort order of these images. If this menu looks familiar, it's because it's kind of like the one for sorting collections in Collections view. Tap on any of these sort options and you'll go back to the Grid View Options menu. You'll see the little up-facing triangle appearing to the right of your choice, which you can tap to choose ascending or descending for your sort order (again, just like when you're sorting collections).

Using Segmented View

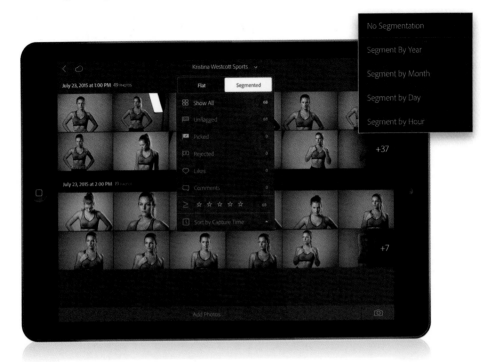

This view allows you to see your images grouped together automatically by when they were taken. To enter this view, tap on a collection's name at the top of the screen (or tap on Lightroom Photos) and then tap on **Segmented** (the regular view is called "Flat"). The date the first image was taken will appear at the top left. Tap-and-hold on it to choose which time frame you want them segmented by (year, month, day, or hour) from the pop-up menu (as seen here in the overlay) and it takes it from there (you can still filter to just see your Picks, 5-star images, etc., from the Grid View Options pop-up menu in the top center of the screen. More on filtering in a minute). If you increase or decrease the size of thumbnails in this view (by using the "two-finger pinch"), they will collapse/expand within their groups. To return to Flat view, choose No Segmentation from that same pop-up menu (or tap on it in the Grid View Options pop-up menu).

Manually Rearranging Your Thumbnails

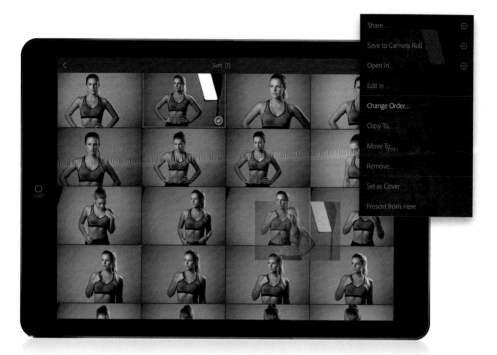

If you want to manually sort your image thumbnails to put them in the exact order you want, image by image, here's what to do: Tap-and-hold on any image in a collection, and when the pop-up menu appears, tap on **Change Order**. Now you can tap-and-hold on any thumbnail to select it (a blue border will appear around it, along with a checkmark in the bottom right, to let you know it's selected), and then drag it where you want it. As you move through the grid, you'll see a solid blue line appear between or before the thumbnails to let you know that if you let go of the screen right now, that's where the thumbnail would appear (as seen here). To move multiple thumbnails at one time (while you're in this Change Order mode), just tap on each one to select them, then tap-hold-and-drag them. When you're done sorting like this, tap the Back arrow to return to the normal collection Grid view.

Setting a Cover Photo

You can choose which image appears as the thumbnail for a collection (when you're in Collections view). By default, it chooses the first image in the collection, but if you'd like a different image as the cover, just go to Grid view, tap-and-hold on the image you'd like for your collection cover, and choose **Set as Cover** (as seen circled in red here).

Copying and Moving Images

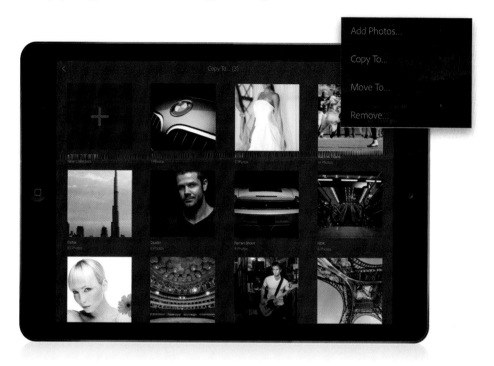

When you're looking at a collection in Grid view, there are some options that let you copy or move images from one collection to another without having to go back to Lightroom on your computer. For example, tap on the Collection Options icon in the top right (the one with the arrow pointing up), and if you tap on Copy To in the pop-up menu (seen in the overlay here), and then tap on the image(s) you want to copy, then tap on the right-facing arrow in the top-right corner, it displays all your collections in Lightroom on your mobile device (as seen here). Tap on the one you want to copy it to (there's also an option to add it to a New Collection), and you're done. Same process with choosing Move To. If you choose Remove, you then choose which image(s) you want removed from this collection, and tap on the trash icon in the top-right corner. *Note:* It removes those images from your collection here, and back in Lightroom on your computer, but it does not delete the original file—that's still in the original folder on your computer. After you select some images for any of these options, if you change your mind, just tap the "X" icon in the upper-left corner to cancel.

Selecting Multiple Images

When you're copying, moving, or removing images to or from a collection, if the images you want to select are near each other, you can tap-and-drag over the thumbnails to select multiple images at once. To select them all, tap-and-hold to bring up a pop-up menu, then tap **Select All** (seen in the overlay here). You can deselect images the same way. You can also select a range of images from here, too—a blinking checkmark will appear on the first image you tap on and when you tap on the last image you want to select, it selects everything in between them.

Seeing an Image in Loupe View

To see an image in the grid larger, just tap on it and it zooms up to the size you see here (this is called Loupe view), and it displays the filename at the top of the screen (along with how many images are in this current collection). It also displays whether the image is a smart preview or a high-res file, along with the EXIF camera data up near the top-left corner of the screen, much like you'd see in Lightroom on your computer, and a histogram of the image up near the top-right corner. To hide the metadata and histogram, just tap with two fingers (or tap on the third icon in the top left—the circle with an "i") to cycle through the EXIF data and histogram, or to hide it all. Down below the image are the editing controls (more on these in the next chapter), and the sharing options (along with some other options) are found by tapping on the Collection Options icon up in the top-right corner (the one with the arrow pointing up). To see the next image in the grid at this full-size view, just swipe to the left (or to the right to see the previous image).

Zooming In

To zoom in to a tighter view, just double-tap the screen; same thing to zoom back out. You can also "pinch" the screen to zoom in/out (here, I also hid the EXIF data and histogram).

Hiding the Loupe View Interface

If you want hide the Loupe view info and options and just see your image presented full screen, tap once on your image and it all quickly hides away (as seen here). Of course, you can still swipe left/right to see more images in this collection. To return to the regular Loupe view, just tap the screen once. To return to Grid view, once you're back in regular Loupe view, just tap the Back arrow at the top left of the screen (you can kinda see that arrow on the previous page). So, to get from this full-screen view back to Grid view, it's two taps: (1) tap on the image once to return to Loupe view, (2) then tap the Back arrow.

Using the Filmstrip

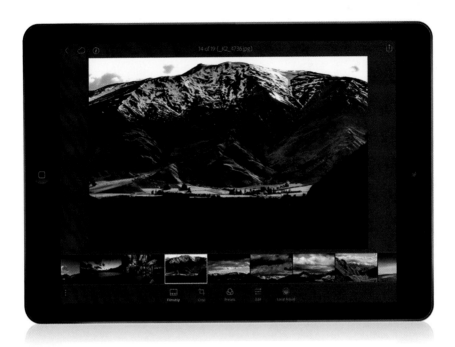

When you're in regular Loupe view, there are five icons beneath your image. Tap on the Filmstrip icon (the first one on the left) to bring up the Filmstrip below your image with all the thumbnails for the images in that collection. (*Note:* Currently, the Filmstrip feature is only available on a tablet.) You can scroll through the images in this Filmstrip by swiping left or right directly on it. To hide it, either tap on the Filmstrip icon again or tap on the image to enter full-screen view (which, again, hides all the interface controls).

Starting a Slide Show

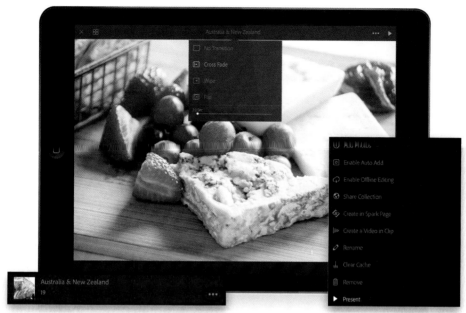

When you tap on the three dots to the right of a Collections view thumbnail (on the left), a menu pops up with a list of options (seen on the right) where you'll find Present

Tapping on **Present from Here** (**Slideshow** on an Android device) in the Collection Options pop-up menu (tap on the icon in the top right—the one with the arrow pointing up), and then tapping on the right-facing arrow in the top-right corner, starts a self-running slide show of the images in this collection with a soft dissolve between each image. Another way to start a slide show is from the Collections view screen—just tap on the three dots to the right of a collection's thumbnail and a menu pops up with a set of options. At the bottom of the menu, you'll see Present (as seen in the overlay here; it's Play Slideshow on an Android). Also, once the slide show is running, if you tap on the screen, then tap on the three dots in the top-right corner (or Slideshow Options on an Android), a pop-up menu of options appears (seen here), where you can choose the length of time between images (using the slider), and your preferred style of transition between images (to turn off the transitions altogether, just choose No Transition).

Flagging Your Images as Picks or Rejects

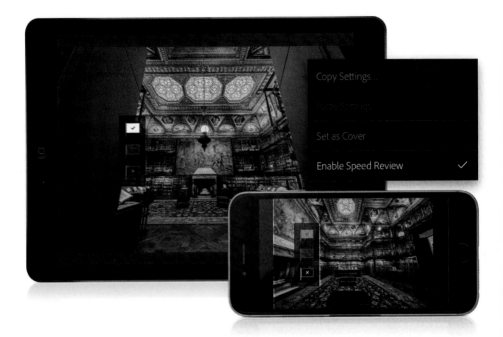

When I'm going through my images from a shoot and flagging my Picks (the "keepers" from a shoot), I don't like any distractions onscreen—I want my focus to be on the images—so I do my reviewing in full-screen mode (in Loupe view, tap once on the image). But, the technique I'm going to show you not only works in full-screen, but also in regular Loupe view, or with the Filmstrip visible, too. First, tap-and-hold on the image onscreen and, in the pop-up menu that appears, make sure **Enable Speed Review** is turned on. Now, as you swipe left/right through the images in your collection, when you see one you want to flag as a Pick, just swipe up on the left side of the screen. Three flags will appear onscreen (as seen here), with the top one selected, letting you know you tagged it as a Pick. If you tag an image as a Pick and then change your mind, just swipe down to the middle flag to "unflag" it, and you'll see that the middle flag becomes selected. Swipe down again, and it'll flag the image as a Reject (as seen in the phone at the bottom right).

Adding Star Ratings

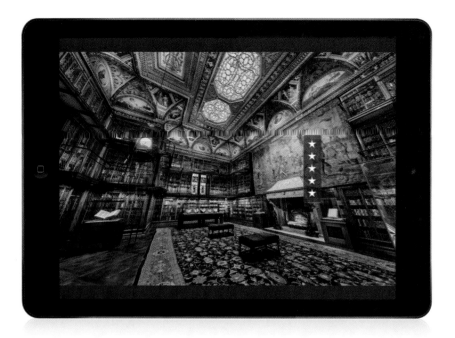

If you'd prefer to use star ratings instead (from 1 to 5 stars), you can do that by going to Loupe view (seen here) and, when you're swiping through your images and you see one you want to rate with a star rating, just slowly swipe up and a ratings bar appears near the right side of the screen (remember to turn on Enable Speed Review first, as we just saw on the previous page). The higher you swipe, the more stars it adds. If you add too many by mistake, just slowly swipe down to remove them one by one. To switch back to Pick flags for tagging, just swipe near the left side of the screen (again, as we saw on the previous page).

Using Filters to See Your Best Images

Once you've applied your Pick flags and/or star ratings, you can apply filters so you only see what you want to see. To get to these filters, tap on the name of the collection up at the top center of Grid view to bring up the Grid View options. Then, just tap on the filter you want to turn on. For example, tap on Picked and it just displays the images you marked as Picks in that collection. Here's the cool thing: you can assign more than one filter. Also tap on Unflagged, and now you're seeing both your Picks and images you haven't tagged with anything. Tap on just Rejected to see only those you flagged as Rejects. Here, I tapped on Picked, but then I also set it to four stars and it narrowed things down to just that one image, which has both a Picks flag and a 4-star rating. These filters are incredibly handy. (*Note:* The Likes and Comments filters are currently only available for iOS.)

Seeing Your Picks and Star Ratings on Your Desktop

When you go back to Lightroom on your computer, you'll notice that all the flags (Picks and Rejects), plus any star ratings, have been synced back to your collection there.

SHUTTER SPEED: 1/800 sec | F-STOP: f/3.5 | ISO: 800 | FOCAL LENGTH: 14mm | LOCATION: Dubai, United Arab Emirates

Chapter Three

Editing Your Images

It's Lightroom Mobile's Version
of Lightroom's Develop Module

I have to admit, I've been really impressed at how much of Lightroom's Develop module has made its way over to Lightroom Mobile. Almost all of the things you've come to expect in Lightroom Desktop, from the entire Basic panel, the Tone Curve panel, and the Color/B&W panel, to Split Toning and presets, and even Local Adjustments, like the Graduated Filter and the Radial Filter, are here—but, for reasons I've yet to understand, Adobe decided to change their names to Linear Selection and Radial Selection. Those are the only two things that I can think of that have different names in Lightroom Mobile for the same tools in Lightroom Desktop. Well, with one big exception: In Lightroom Desktop, the panel with the Dehaze filter is named Effects, and that panel hasn't made it over to Lightroom Mobile, but Dehaze has. But, in Lightroom Mobile, they changed the name to the Japanese phrase "shinnen omedetō gozaimasu," which roughly translates to "Godzilla put an omlette on my shin." Now, if you ask me, that's a weird name for the Dehaze slider. Personally, for the sake of clarity, I would have named it the more obvious "yakushite kudasai," whose literal translation is "I think a yak just pooped on your kudasai," which I think we all can agree would be a far better name, especially for new users.

Editing Your Images

To edit an image using the same controls as you would in Lightroom on your computer, just tap on an image in Grid view to enter Loupe view (seen here), and then tap on the Edit icon in the Action options at the bottom of the screen. This brings up the same controls you have for editing in Lightroom's Basic panel on your computer (it's all there—everything from White Balance to Exposure; Shadows to Whites and Blacks; Clarity to Vibrance; it's all there), in the same order, they just run across the bottom of the screen instead of along the right side like they do on your computer. Adobe calls each of these controls "adjustment tiles," so you tap on a tile to access its features (or slider).

Setting the White Balance

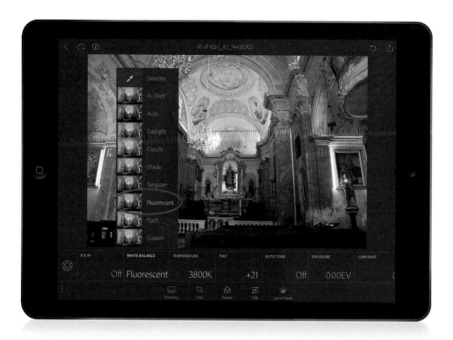

This image has a yellow tint to it (as seen on the previous page), so we have to fix the white balance. In the row of adjustment tiles across the bottom, tap on the White Balance tile and a menu pops up with a list of White Balance presets and a thumbnail preview of how each would look if applied to your image. Just taking a quick glance at these, it looks like the Fluorescent preset would look best (well, at least the yellow tint is gone with it), so I tapped once on the Fluorescent preset to apply it (as seen here).

Using the Temperature and Tint Sliders

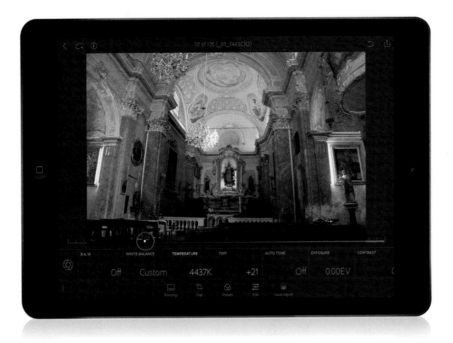

The nice thing about applying a White Balance preset like we just did on the previous page is if it's not right on the money, you can still tweak it. In this case, it might be a little too cool now, but you can just tap on the Temperature tile and a slider appears right above the row of tiles. Just tap-and-hold on the little knob on the slider (seen circled in red here) and it works just like the sliders in regular ol' Lightroom on your computer—drag to the right to make the white balance warmer; to the left to make it cooler (you'll notice that the slider is colorized here, too, with blue on the left and yellow on the right). In this case, I dragged a little to the right, so it's not so cool (the Temperature reading was 3800K, but now it's up to a little warmer 4437K).

Resetting an Edit Slider

If you make a mistake, or don't like the change you applied, just double-tap anywhere along the slider to reset it to where you started, as seen here (I turned on Show Touches in the Sidebar to get the red dots to appear), or you can just double-tap on the name of the adjustment tile.

Using the White Balance Selector Tool

One last thing about White Balance: the White Balance Selector tool is here in Lightroom on your mobile device, too. Look back on page 37—it's at the top of the White Balance preset pop-up menu. Just tap on it, and it appears over your image. It has a loupe to help you isolate where you're picking your neutral gray color from. Here, I tapped-and-dragged it to the right—as you drag-and-release, it gives you a live preview of what it would look like if you tapped on the white circle with the checkmark at the top right of the loupe (which confirms you're choosing that spot to base your white balance upon). So, I guess you know now that when it looks good to you, tap on that checkmark to lock in your choice. When you do, the White Balance Selector tool disappears.

Adjusting the Overall Brightness (Exposure)

If you want to adjust the overall brightness or darkness of your image, tap on the Exposure tile, and then drag the slider to the right to make your image brighter, or to the left to make it darker. This slider doesn't actually cover the darkest areas or the brightest ones (those are covered by the Blacks and Whites sliders), but it covers the midtones, and that's a wide range, so it has a pretty big impact (in fact, in early versions of Lightroom, this slider was actually just called "Brightness," but when you speak to us photographers and you say "exposure," we know exactly what that means, so it's probably better named now. But, just so you know—it controls the overall brightness).

Automatically Correcting Your Images with Auto Tone

If you're looking at one of your images and you don't know where to start, a good starting point might be to tap on the Auto Tone tile and see how that looks. It performs an auto-correction on your image and sometimes it does a surprisingly decent job. The key word there is "sometimes." If it looks terrible—no harm done—just tap on the Auto Tone tile to turn it off. But, this doesn't have to be a "it looks good or it looks bad" kinda thing. It can at least give you a starting place, which is especially handy on a tricky photo. If you tap on Auto Tone and it doesn't do a good job, chances are it's because it made the image too bright overall and, if that's the case, you can usually get things back to looking better by either: (a) lowering the Whites slider amount back down to 0, or (b) dragging the Exposure slider back to the left to lower the overall brightness until things look good. It's usually one of those two sliders that makes it look too bright and kills the auto toning job. So, pulling those back often gives you a better result (but again, only do this if it looks too bright).

Adding Contrast

If your image looks kinda flat, this will fix it fast. Tap on the Contrast tile, and then drag the slider to the right to add contrast (or drag it to the left if you're going for that flat Instagram filter look). Not much else to tell you with this one, other than lack of contrast is pretty much the #1 post-processing problem I see when people send me their images and ask for a critique. In my own work, I pump up the contrast quite a bit for most images. Contrast, in general, makes the brightest areas in your image brighter, the darkest areas darker, and it makes your colors look richer and more saturated. I guess I did have a little bit more to tell ya after all. For more on contrast, see the next chapter on how to use the Tone Curve feature.

Fixing Brightest Areas (Highlights)

The very brightest parts of your image are adjusted using the Highlights tile (well, the slider knob that appears above the tile when you tap on it), so if things get too bright in your highlights (for example, they're so bright that the highlights in your image start clipping, the same way you'd see with your camera's highlights warning), this is the slider you'd use to bring back those highlights. Just drag the Highlights slider to the left to recover those highlights (see the next page for how to turn the highlight clipping warning on). Of course, if you drag the Highlights slider to the right, it will increase the amount of the very brightest areas in your photo. I rarely do this because we're usually dealing with a highlight problem, so we're reducing the amount of highlights—capturing highlights isn't a problem for our cameras. In fact, our cameras' problem is they often capture too much in the highlights, so we lose detail and dragging the Highlights slider to the left is how we get it back. So, don't be surprised if you rarely find yourself dragging this slider to the right to add in more highlights.

Dealing with Highlight Problems (Clipping)

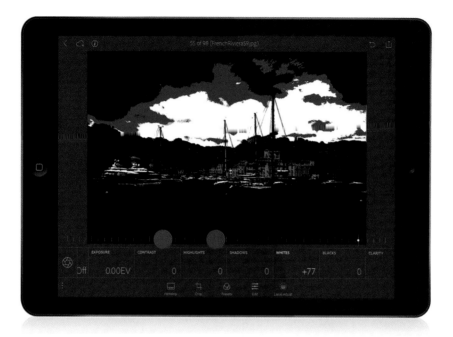

One of my favorite features in Lightroom on your computer is here in Lightroom on your mobile device—it's just kind of hidden—and that's the ability to get a clipping warning if you're blowing out your pixels. You can see this warning onscreen when adjusting Exposure, Shadows, Highlights, Whites, and Blacks. Just press two fingers anywhere on the slider for that control (I turned on Show Touches in the Sidebar to get the red dots to appear here), and it will black out the screen and display only areas that are clipping, like you see here where cranking up the Whites too much clipped some buildings in just the Red channel, and some sky areas in just the Blue channel, but clipped all three channels in the other parts of the sky and in parts of the boats (the areas in white), which is some pretty serious damage, and now I know to back down the Whites to avoid this clipping.

Fixing Backlit Photos or Opening Up Shadows

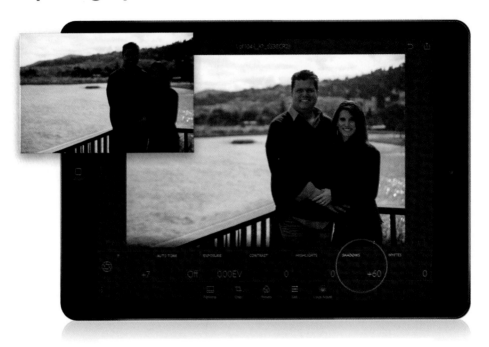

Tapping on the Shadows tile lets you open up the shadow areas in your photo, and I use this quite a bit to bring out hidden details in dark areas, or to instantly fix backlit photos (it works wonders for this type of stuff). Just drag this slider to the right and the shadows are opened up and the detail comes out. Of course (and I know this goes without saying, but I'm going to say it anyway), if you drag it too far, not only can it start to look kinda funky (of course, it depends on the image—sometimes dragging it to +100 looks great), but it can also make those areas look a bit washed out. If that's the case, and you have an image where you really needed to open up those shadows, and now those areas look washed out, tap on the Contrast tile, and then drag the slider a little to the right to bring back some of that lost contrast and counteract that washed-out look.

Expanding Your Tonal Range (Whites and Blacks)

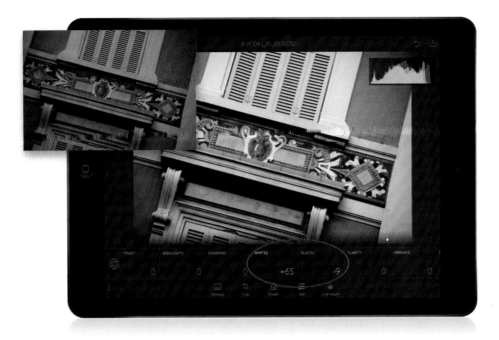

You can expand the overall tonal range of your photos using just the Whites and Blacks adjustment tiles, and just doing this one thing can have a pretty dramatic effect on your photos (for those of you who learned Photoshop first, this is what we used to do in Photoshop's Levels dialog by dragging the highlights slider to the left until we hit the edge of the histogram. Then, we did the same thing with the shadows slider, dragging it to the right until we hit the edge of the histogram, and then we tweaked the overall exposure using the midtones slider). We're going to do a version of that here. So, tap on the Whites tile, then drag that slider to the right and stop just before it clips (you can see the histogram by tapping with two fingers on the screen to toggle through the readouts until it appears in the top-right corner, as seen above). Don't let the right edge of the graph hit the right-side wall of the histogram. Do the same thing with the blacks, but again, don't let the left side of the graph hit the left wall. Once you have those in place (which expands your tonal range), now you can go back and tweak your midtones using the Exposure tile. By the way, this is the order I use for tweaking my own images: adjust the whites and blacks first to expand my tonal range, then I usually just need a minor adjustment with the Exposure setting making it a little darker or brighter. Give that a try and see what you think.

Bringing Out Texture with Clarity

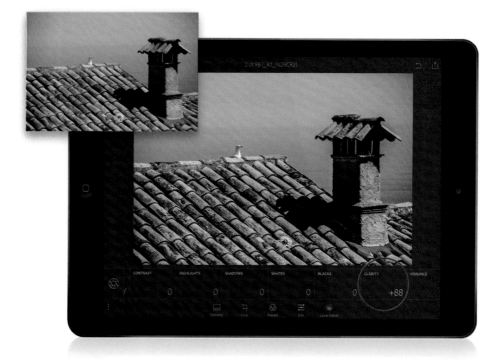

If you have an image where you want to bring out and emphasize detail or texture, this is the adjustment for you. Tap on the Clarity tile and then drag the Clarity slider over to the right and any texture in the image gets immediately intensified. This slider actually increases midtone contrast, but while doing that it enhances detail and makes everything look a bit punchier. Just a word of caution—you can drag this slider too far and things start to look funky. You'll know you've gone too far if you start seeing a black glow or halo appear around the edges of stuff in your image. How far you can drag that slider and have it still look good really just depends on the image—landscapes, automotive or motorcycle shots, cityscapes, architectural shots, or anything with lots of very well-defined edges can usually take lots of Clarity. Images where the subject is softer (like people's skin) usually don't look too good with a lot of Clarity, so keep that in mind (the reason I'm warning you is, Clarity is pretty awesome. It's so awesome that it's easy to get carried away with it, and pretty soon that portrait of your newborn nephew starts to look like an HDR from 2008).

Adding More Color to Your Image

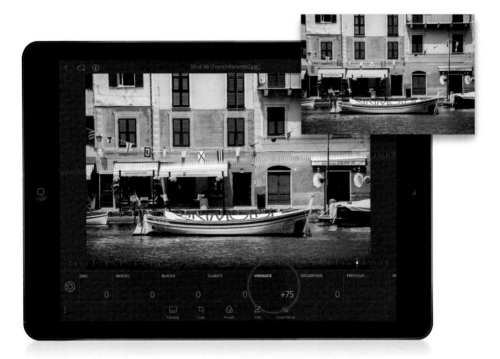

There are two sliders that add or take away color: Vibrance and Saturation. But, here's my tip: If you want to add color, stay away from the Saturation slider. It usually does more harm than good because it's very blunt, making every color in your image really colorful and clowny. Instead, use Vibrance. It's like a "smart saturation" because it doesn't affect colors that are already reasonably colorful. Instead, it focuses on increasing the color of dull colors in the image (that's what you want, right?), and it has a special mathematical algorithm that avoids flesh tones. Tap on the Vibrance tile, drag the slider to the right, and your image gets more vibrant without trashing the color (it works really well).

Desaturating an Image

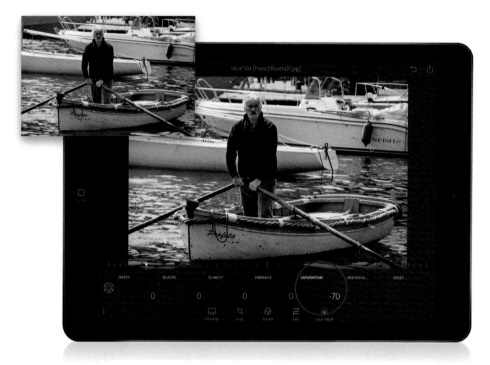

If you want to remove color from your image (I do this a lot with portraits since that's kind of a "thing" right now), tap on the Saturation tile, and then drag the slider to the left. The farther you drag, the more color it removes. If you drag it all the way to the left, you remove all the color and you'll have a black-and-white image. Now, at some point, you might be tempted to drag this slider to the right to make your image more colorful. Resist this temptation, and instead read the previous page about the Vibrance slider, which is its much smarter, much more accomplished, much thinner and happier sibling, which clearly went to a better school.

Adding Pick Flags and Star Ratings While Editing

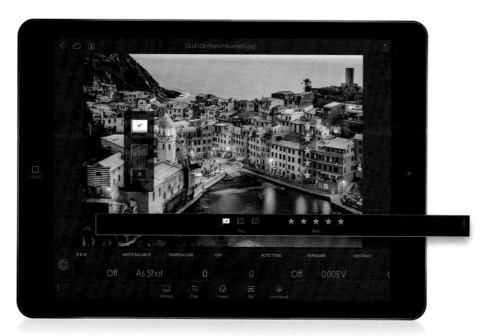

While you're editing in Loupe view, you can also apply a Pick flag or a star rating. First, tap-and-hold in the center of the image and, from the pop-up menu that appears, make sure **Enable Speed Review** is turned on. Then, just tap on the left side of the image and drag up to add a Pick flag, or tap on the right side of the image and drag up to add a star rating. You could also add them by tapping on the three dots on the left side of the Action options. The options bar will slide to the right and you'll now see the Flag and Rate options (seen here in the overlay). But, when you tap on the three dots now on the right side of the Action options, you'll then need to tap on the Edit icon again to access the adjustment tiles.

Applying Changes Made to One Photo to Other Photos

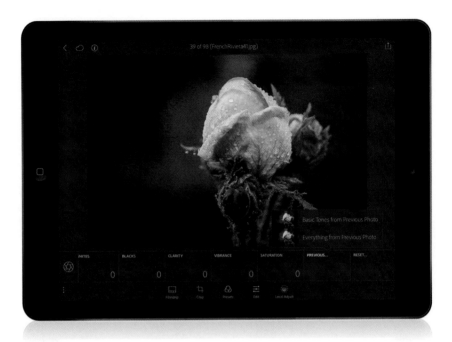

One of the most powerful time-savers from Lightroom on your computer is here, too: the Apply Previous feature. It takes the adjustments you made to the previous image, and applies them to the current image with one tap (super handy and fast!). To use it, tweak a photo the way you like it, tap on the Filmstrip icon to bring it up along the bottom, then swipe to the image you want to apply this look to, and tap on it. Now, tap back on the Edit icon and scroll the tiles to the right (er, I mean swipe to the right) down near the very end, where you'll see a tile named simply "Previous…." Tap on it, and a pop-up menu appears (seen here) asking if you want just basic tonal edits from the tiles below, or everything you did to the previous photo, including cropping, rotating, etc. Make your choice and the edits are applied immediately.

Seeing a Before/After

To see a before image (what the image looked like before you started adjusting it), just tap-and-hold three fingers right on your image, as seen here (I turned on Show Touches in the Sidebar to get the red dots to appear). You'll see "Before" appear above the image (as seen circled here), and when you release your fingers, you'll go right back to your edited image.

Resetting Your Image

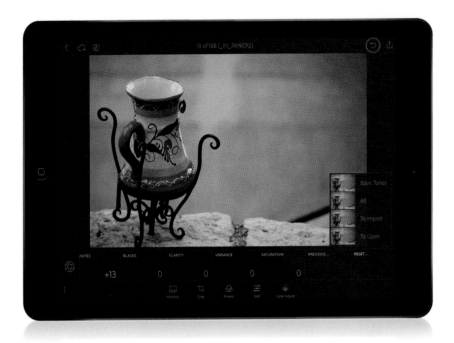

If you swipe over to the very end of the Edit tiles, there's a Reset tile, which lets you start over. Just tap once on it and a pop-up menu appears (seen here) asking if you just want to reset the Basic Tones, or reset everything (cropping including), or if you want to reset the image to how it looked when you first imported it in Lightroom, or when you last opened it. It's great to know how to reset your image, but something that's probably at least as, if not more, important is the curved-arrow icon in the top-right corner (circled here). That's the Undo icon. Each time you tap on it, it undoes another step, so you can go back in time, step by step, and undo anything you didn't like in the order it was applied.

Editing in Camera Roll

If you're thinking of adding an image from your phone's or tablet's Camera Roll to Lightroom Mobile (by tapping on Camera Roll at the bottom of the screen in either Collections view or Lightroom Photos view), while you're scrolling through your Camera Roll images, if you tap on a photo, you can actually edit it (even though you technically haven't imported the photo into Lightroom Mobile yet) using all the standard editing tools (tap on the Edit icon along the bottom of the screen to bring up the adjustment tiles. *Note:* Currently, this feature is only available for iOS). Why would you want to do this? Well, one reason might be if you see an image that looks too dark, and you're not sure if it's worth importing at all. So, first you'd want to see if you were to brighten it up, or maybe crop it a bit, it might then be worth adding it (or not). So, I kind of use this the same way I would the Quick Develop panel in Lightroom's Library module on my desktop, but in Lightroom Mobile, this actually has more control than Quick Develop—it's almost identical to the regular Edit mode (I wish Lightroom on my desktop would find a way to add this feature).

Editing in a Web Browser

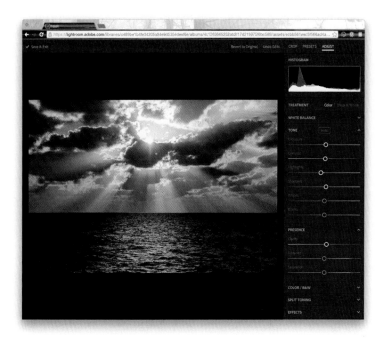

As you'll learn later in this book, the collections you sync to Lightroom Mobile are also available through a web browser (called…you guessed it, "Lightroom Web"). But, it's for more than just seeing your images in a web browser—you can edit them there as well, using many of the same Basic panel features (and basic editing features) that are in Lightroom Mobile (and in Lightroom on your desktop). Start by going to http://lightroom.adobe.com and logging in with your Adobe ID and password. On the Welcome screen, you'll see the Your Synced Catalog panel near the top right that has icons that take you to either your synced collections or to all your images in Lightroom Mobile. When you click on any image, you enter Loupe view (a much larger preview of the image you clicked on), and in the top-left corner, you'll see an Edit button. Click on that and out pops a right-side Panels area that looks an awful lot like Lightroom on your desktop. It has the full Basic panel (with regular ol' sliders), along with a Color/B&W panel, a Split Toning panel, and an Effects panel. At the top of the Panels area (above the histogram), is the Crop tool, along with a bunch of one-click presets (like in Lightroom Mobile). The nice thing is, it's very responsive since the images are already online—you just grab a slider and start editing. Now, you might be thinking, "When in the wide world of sports am I ever going to use this?" Well…I mean…ya know…well…um…heck, I dunno. Maybe you don't have your tablet, or your phone, or your laptop, and you're at a friend's house and desperately need to edit a photo right then and there. Okay, this last part (the reason why) is a little weak at this point, but let's not dwell on that. Instead, let's focus on the fact that you can have Lightroom in a web browser. That's all I've got.

Seeing (and Adding) Metadata in Lightroom Web

While you're editing there in Lightroom Web, not only can you see an image's EXIF data (the make and model of camera, f-stop, shutter speed, ISO, and so on), which you only have limited access to in Lightroom Mobile, but you can also embed an image title and caption directly in Lightroom Web. Just click on the image you want to add metadata to, to enter Loupe view (the larger-sized preview), then click on the Show Activity & Info icon (it looks like a little file drawer) in the lower-right corner, and another set of panels pops out on the right. Click on the Photo Info tab at the top and, in this panel, you'll see fields where you can type in a title and caption. Below that, you'll see an expanded EXIF metadata. When you're done, click the right-facing arrow to the right of the image or just close the right side Panels area by clicking on the little file drawer icon again. Your caption or title will be saved automatically and synced back to your other devices (including Lightroom on your desktop, for those images in a collection).

Chapter Four

Going Beyond the Basic Edits

This Is Where the Good Stuff Is

I've been saying for years that the Basic panel in Lightroom on your desktop (whose controls are the first set of adjustment tiles you see here in Lightroom Mobile's Edit mode) is totally misnamed. Adobe should have called it the "Essentials" panel because these aren't basic controls. I think controlling your overall exposure, and contrast, and color mode are perhaps the most important edits of all the editing you can do. Well, with one exception: I think the ability to crop out an old girlfriend (or boyfriend) you broke up with years ago from a photo of you two should rank pretty high up there. Why is that? It's because of a phenomenon that occurs where, for some unknown reason, the best photo you've ever taken was the one where you two posed for that shot outside the *Disney On Ice* show. But, now you need a profile photo for your Tinder account, but *she's* in it, so you think "Hey, maybe I can crop her out," so you take the photo into Lightroom Mobile, you crop her out, you upload it to Tinder, and sure enough—the connections start pouring in. But, that photo was taken a long time ago, when you were younger, thinner, and better looking, whereas today you're about two Snickers bars away from Jabba the Hutt. So, now you're waiting in Starbucks for your "date" to arrive, and as soon as she sees how you actually look, she begins screaming uncontrollably, and then everybody in Starbucks starts screaming along with her (not even knowing why), and it's at that moment you think, "I wonder what my old girlfriend's up to...."

Using the Tone Curve: Point Curve

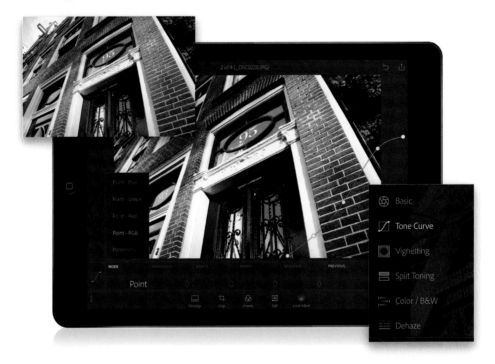

This is the same tone curve you know and love from Lightroom on your desktop. Tap on an image to open it in Loupe view, and then tap on the Edit icon in the Action options at the bottom of the screen. When the adjustment tiles appear, tap on the shutter icon on the far left of the tiles and, from the Adjust pop-up menu, tap on **Tone Curve** (as seen in the overlay here). In the Tone Curve adjustment tiles, tap on the first tile on the left, Mode, and then, in the pop-up menu, choose either the Point - RGB curve (shown here), individual red, blue, or green channel point curves, or the Parametric curve. The interface for the Tone Curve adjustment appears directly on your image over on the right side of the screen. We'll start with the Point - RGB curve (I think it's the more useful of them). You'll notice that all the other tiles are grayed out, and that's because you don't use them with the Point - RGB curve. Instead, you add adjustment points to that diagonal line onscreen, and then you drag those points up/down to adjust. To add a point, just tap once along that line to make your curve. For example, to add a point to adjust the midtones in the image, tap once in the center of the diagonal line and drag downward diagonally to darken the midtones or drag up to brighten them. To adjust the highlights, tap once in the top 1/4 section of the line and drag up to brighten or down to darken, and so on. To remove a point from the curve, double-tap on the point and it's gone. To add contrast to your image, create a curve that looks like an "S" (as seen here). The steeper you make that S-curve, the more contrast it adds. If you mess things up and you just want to start over, tap on the Reset tile at the right end of the adjustment tiles (we looked at how to reset an image in Chapter 3).

Using the Tone Curve: Parametric Curve

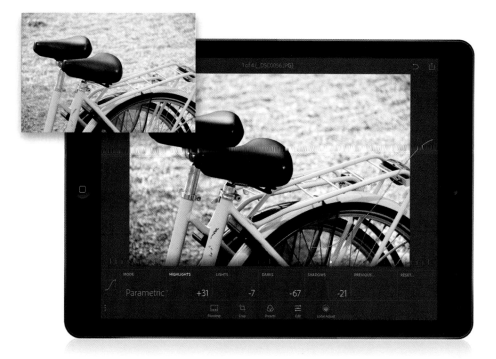

To make adjustments using the Parametric curve, tap on the Mode tile, and then tap on **Parametric** in the pop-up menu that appears. This changes your curve to the Parametric version, and now the tiles along the bottom of the screen become active (you can still adjust this curve by tapping-and-dragging on the curve itself, but it doesn't add points to it). The idea here is to adjust the curve using the tiles and each tile represents part of the curve: dragging a slider to the right increases the steepness of that tonal area; dragging to the left flattens out the tone and the curve in that area. For example, if you tap on the Highlights tile, and drag the slider to the right (as seen here), it raises the top part of the curve, which affects the very brightest parts of the image. The Lights slider affects the 1/4 tones, which is the next brightest area of tones. The Darks slider controls the midtone shadow areas of the curve (the 3/4 tones), and the Shadows slider controls the darkest shadow parts of the image. *Note:* If you used the Point curve first and made adjustments there, any adjustments made here with the Parametric curve are added on top of your Point curve adjustments, so they're additive—it's not one or the other. It treats the adjustments from both curves as separate adjustments.

Using the Tone Curve: RGB Channels

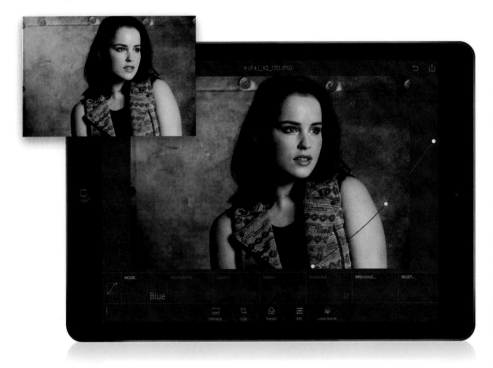

If you tap on the Mode tile, in the pop-up menu that appears, you'll see another set of curve choices: the Red, Green, and Blue Point curves. You'd normally use these to either do specific color correction tasks (but you really have to understand curves, in general, fairly well before you do this or you could trash your image's color big time), or for doing special effects (which you don't have to be an expert to pull off). Probably the most common special effect using curves would be to create cross-processing effects for fashion photography or to recreate Instagram filter looks. When you choose one of these RGB curves, like Point - Blue, your Point curve appears onscreen just like a regular curve, but the diagonal line itself appears in blue (as seen here), so you know you're working on just the blue channel. Tapping in the center and dragging upward adds more blue to the image in the midtones; dragging downward removes the blue, giving you more green (here, I created a slight S-curve for this effect). The other two channels work the same: Dragging the green channel curve upward adds more green; dragging downward removes green, thereby adding magenta. And, dragging the red channel up adds more red; dragging down adds blue (I created an S-curve for each of these channels, as well).

Adding Edge Darkening (Vignetting)

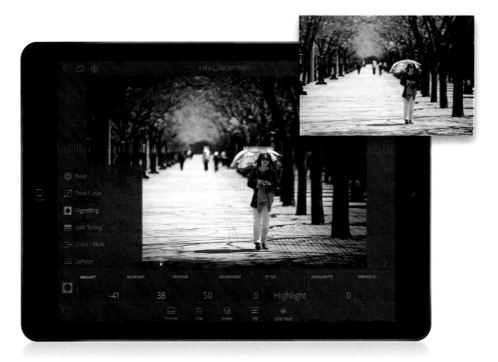

This is the same edge-darkening effect that appears in Lightroom on your desktop's Effects panel (as opposed to the more limited version in the desktop's Lens Corrections panel), so while you can use it to brighten the corners to remove lens vignetting, you're probably coming to this feature to add edge darkening. Tap on an image to open it in Loupe view, and then tap on the Edit icon in the Action options at the bottom of the screen. When the adjustment tiles appear, tap on the shutter icon on the far left of the tiles and, from the Adjust pop-up menu, tap on **Vignetting**. Near the right side of the Vignetting adjustment tiles, tap on the Style tile and a pop-up menu will appear with three different styles. I highly recommend only using the Highlight Priority style (as seen here), as the other two are pretty lame (and that's being kind). Now, to add an edge-darkening effect, tap on the Amount tile, and then drag the slider to the left to darken the edges. Tap on the Midpoint tile and drag its slider to the right to move the effect closer to the corners, or to the left to have the effect extend farther into the image (I only drag to the right if I'm trying to eliminate vignetting in the corners). The Feather tile controls the amount of softness of the edge of the vignette—dragging to the left makes it softer; dragging to the right makes it harder. And, the Roundness tile does just what you'd think it does—dragging to the right makes it rounder and softer; dragging to the left makes it harder and more defined, until it looks like a rounded rectangle.

Converting to Black and White

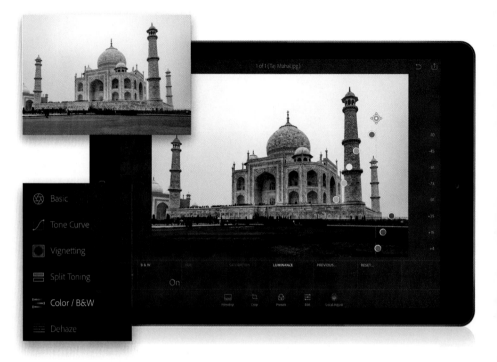

To convert your image to black and white, tap on an image to open it in Loupe view, and then tap on the Edit icon in the Action options at the bottom of the screen. When the adjustment tiles appear, tap on the shutter icon on the far left of the tiles and, from the Adjust pop-up menu, tap on **Color/B&W** to bring up a vertical row of color dots over the right side of your image. Now, in the left side of the adjustment tiles, tap on the B&W tile to convert the image to black and white, but you'll notice that the vertical row of color dots still appears over the image. That's so you can tweak the black-and-white version of the image by moving the color sliders. For example, in this image, if you drag the blue dot, it controls the sky (even though the sky is now black and white). Dragging to the left darkens the sky; dragging to the right lightens it. You'll drag some color dots and nothing will happen in the image—that's because that color didn't appear in the color image. So, since moving it would have no effect on the color version, it surely won't have an effect on the black-and-white version. But, if the image has green grass, and you drag the green dot, this will affect the darkness/brightness of the green areas in your black-and-white image. If you're not sure what affects what (or you forget which colors are in the color image), just tap-and-drag the dots, and you'll instantly see which sliders adjust which areas.

Creating Split-Toning Effects

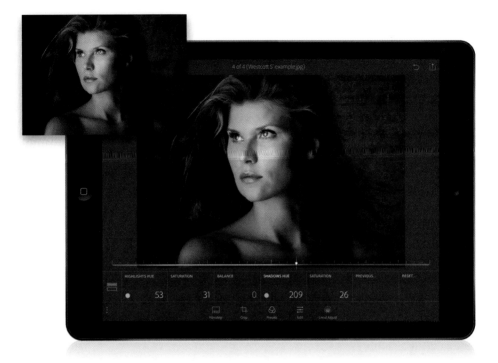

You can use this feature to add split-toning, tints, or duotone effects to a color or black-and-white image. Generally, you would apply one color tint to the shadow areas (like a blue tint), and a separate color tint to the highlights (like a yellow tint). However, you won't see anything at all until you raise the Saturation amount for either the Shadows or Highlights, so we'll start there first. Tap on an image to open it in Loupe view, and then tap on the Edit icon in the Action options at the bottom of the screen. When the adjustment tiles appear, tap on the shutter icon on the far left of the tiles and, from the Adjust pop-up menu, tap on **Split Toning**. Near the left side of the Split Toning adjustment tiles, tap on the Highlights Saturation tile (it's the second tile), drag the slider to the right a bit, and you'll start to see some color. Now, tap on the Highlights Hue tile and choose the color you want in your highlights. Next, do the same things for the shadows, raising the Shadows Saturation, and then choosing the Shadows Hue. Lastly, you can control the balance between the highlights and shadows by tapping on the Balance tile and dragging its slider. If you're going for a duotone effect, start by converting the image to black and white (see the previous page), then come back here to the Split Toning adjustments, increase just the Shadows Saturation, and then drag the Shadows Hue slider to a brownish hue. Don't mess with the highlights at all—just do the shadows and you're done.

Adjusting Individual Colors in Your Image

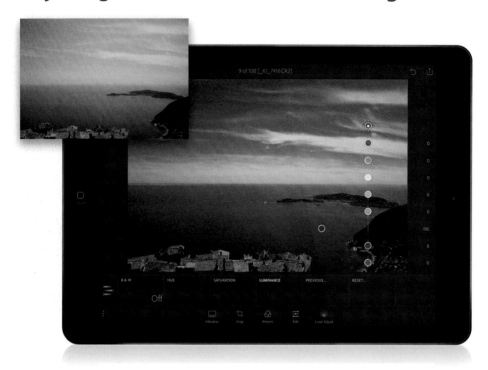

If you want to increase one (or even two or three) particular range of color (for example, I often want to add more blues to a sky), in the adjustment tiles at the bottom of the screen, tap on the shutter icon on the far left and, from the Adjust pop-up menu that appears, choose **Color/B&W** (this is the HSL/Color/B&W panel in Lightroom on your desktop). This brings up a series of color dots over your image that you can drag to adjust the individual colors in the image. So, if you want to change the blues in your image, before you start dragging the blue dot, you need to tell Lightroom Mobile what you want that blue dot to do. If you tap on the Hue tile, and then drag the blue dot, it's going to change the blues in your image to a different color. If you tap on the Saturation tile, it's going to change the amount of blue in the blue areas. And, if you tap on the Luminance tile, dragging that dot now changes the brightness of the blues. So, it's important you tap on the tile for which one of those you want to adjust first, before you start dragging the dot. In my example, to make the blues in the sky darker and richer, I tapped on the Luminance tile, then dragged the blue dot to the left (it works wonders), then I tapped on the Saturation tile and dragged the blue dot to the right. But, like anything in Lightroom, if you drag it too far to the left, it can start to posterize (you start seeing harsh transitions between colors), so don't go crazy with it.

Fixing Hazy Images

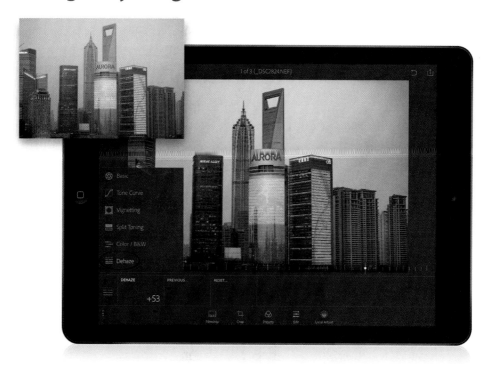

This is a one-trick pony, but it's a good one: Tap on an image to open it in Loupe view, and then tap on the Edit icon in the Action options at the bottom of the screen. When the adjustment tiles appear, tap on the shutter icon on the far left of the tiles and, from the Adjust pop-up menu, tap on **Dehaze**. Now, just tap on the Dehaze tile, then drag the slider to the right, and it removes haze, mist, etc., from your image (it's a special form of contrast, and although it's designed to cut through haze, I use it for all sorts of situations where the image needs more contrast). Drag the slider to the left and (you guessed it) it makes the image foggy (great for morning mist effects). That's pretty much all there is to this one, but the math behind it is pretty amazing, and this Dehaze feature has won a lot of fans since it was introduced.

Fixing Skies (and Other Stuff) with the Graduated (Linear) Filter

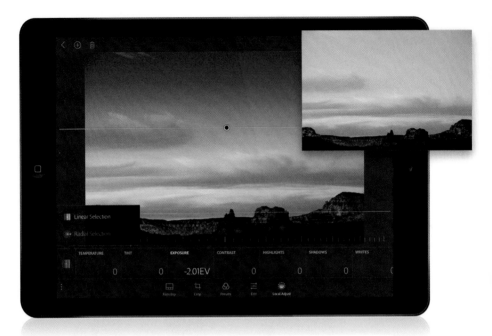

To darken a sky and have it fade off to transparent at the horizon (like a neutral density gradient filter on your lens would), use the Graduated Filter (well, that's what it's called in Lightroom on your desktop; in Lightroom Mobile, it's called the Linear Selection). Tap on an image to open it in Loupe view, then tap on the Local Adjust icon at the bottom of the screen. (*Note:* Currently only available for iOS.) Make sure the Linear Selection icon is selected on the left side of the adjustment tiles (if it's not, tap on the icon, then tap on **Linear Selection**). Now, tap at the top of the screen and drag down to the horizon line to create a graduated selection. The farther you drag, the further into your image the effect will appear. A red tint will appear showing which areas will be affected most, and then it graduates down to transparent. To rotate it, tap on the center white line and drag in a circular motion. To change how abruptly the gradient changes from affected area to transparent, tap-and-drag the outside white lines in/out. Once you drag out your gradient, tap on the Exposure tile and drag the slider to the left to darken the sky. You can also use any of the other adjustments, like Color Hue, which lets you change the color of the sky in that affected area. Of course, you don't have to just use this on skies—I also use it on portraits to create a fall-off effect where the subject's face is bright, and then it gets darker as it moves down. If I didn't do this when I lit the subject, then I drag the gradient from the bottom of the image and stop just below their face, then I lower the Exposure amount, which darkens the bottom of the image and then lightens as it nears their face. A couple more things: To duplicate a gradient, tap-and-hold on the center pin and choose **Duplicate Selection**. To delete it, tap on the trash icon near the top-left corner of the screen. To create another Linear Selection, click on the + (plus sign) icon, also in the top left.

Creating Spotlight Effects Using the Radial Filter

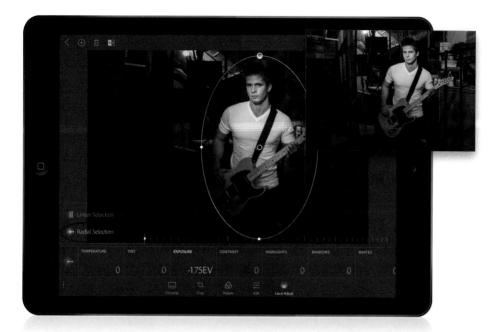

This filter creates an oval, and you can choose to affect the area inside it or just affect everything outside of it (which is how I use it, so I can create a spotlight effect for portraits or product shots). Here's how it works: Tap on an image to open it in Loupe view, then tap on the Local Adjust icon at the bottom of the screen. (*Note:* Currently only available for iOS.) Tap on the icon on the left side of the adjustment tiles, then tap on **Radial Selection**. Now, tap where you want the center of your oval to appear and drag outward to create an oval shape. At this point, I tap on the Inverse icon (the fourth icon from the left) in the top-left corner to switch the selection, so any changes I make affect what's outside the oval, instead of what's inside (but, of course, which area you want to affect is up to you). To reposition the oval, just tap-and-drag the center pin (a red tint will appear showing which areas will be affected). To rotate the oval, tap-and-drag in a circular direction on the oval's white line. To control the softness (feathering) of the oval's edge, tap-and-drag the large, round pin at the top of the oval—drag it around the oval (the Feather amount will appear at the top of the screen—the higher the number, the softer the transition between the center of the oval and the area outside the oval). To resize the oval, tap-and-drag any of the small pins. Once your oval is in place, you can use the Edit adjustment tiles along the bottom of the screen to make your adjustments. To create a spotlight effect inside the oval, I darken the outside by dragging the Exposure slider to the left a bit. That's all there is to it. To make a duplicate copy of your Radial Selection, tap-and-hold on the center pin and choose **Duplicate Selection** from the pop-up menu. To delete it, tap on the trash icon near the top-left corner of the screen. To create another Radial Selection, click on the + (plus sign) icon, also in the top left.

Applying Auto Lens Corrections

If Lightroom has a built-in lens profile for your particular make and model of lens, then you can have it automatically apply the lens profile to your image on import. Here's how: Go to Collections view and tap on the little LR icon in the top-left corner of the screen to bring out the Sidebar. Now, near the middle, tap on Import to bring out those features, and then tap on **Enable Corrections** to turn this on (as seen in the overlay). Then, beneath that, choose whether you want it applied to just RAW photos or all photos.

Editing RAW Photos from Your DSLR

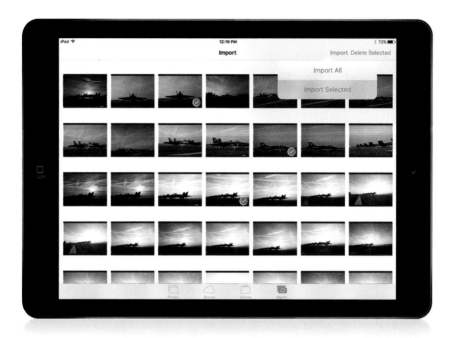

To edit RAW photos from your DSLR or mirrorless camera, you'll need to import the images directly from your memory card into Lightroom Mobile. (*Note:* Currently, this feature is only available for Apple iOS devices and, at this point in time, Apple devices don't recognize RAW files natively [though they have said publicly that this feature is coming soon], so you can't just email yourself a RAW file or access it through Dropbox or another cloud service— you have to connect your memory card to your iPhone or iPad [using Apple's iPad Camera Connection Kit, their Lightning to SD Card Camera Reader, or by attaching your camera with the Lightning to USB Camera Adapter] to get them onto your mobile device first, then you can get them into Lightroom Mobile from there.) Here's how: Once you've connected the memory card from your camera, your iPhone or iPad's Import tab will appear (as seen here), where you can choose which RAW images you want saved to your Camera Roll (RAW images are much larger in file size than JPEGs, so I wouldn't pick 200 images to import, or it'll eat up the space on your mobile device like nobody's business. So, I recommend just choosing your very best shots [your hero shots], unless you've got a ton of free space on your iPhone or iPad). Once you've done that, you can import those RAW images into Lightroom Mobile directly by tapping on Camera Roll at the bottom of the screen in the Collections view and choosing them for import by swiping over them to the right (RAW images have the word "Raw" appear on them).

Applying Develop Module Presets

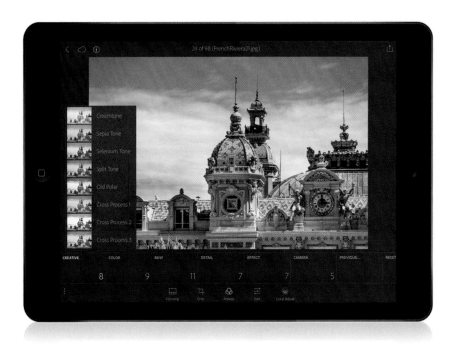

This next thing is pretty cool: In Loupe view, the Presets icon (the third one from the left in the Action options across the bottom) gives you access to a ton of Develop module presets (each tile has a pop-up menu, as seen here where I tapped on the Creative tile). These are one-tap effects that we just tap and—boom—done! Of course, once we apply a preset, we can still adjust our Basic panel adjustments (Exposure, Highlights, etc.).

Using Preset Previews

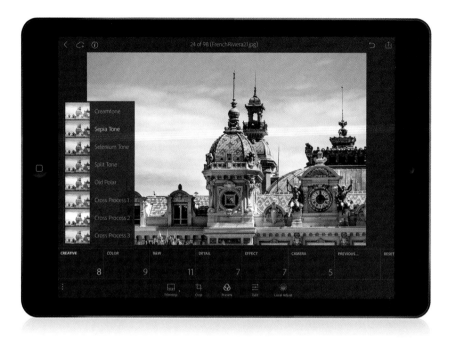

I tapped on Sepia Tone to apply the look you see here. One thing I really like about how Adobe designed these preset pop-up menus is that you can see a mini-thumbnail preview right there for each preset. That way, you can see which ones look good without even tapping anything—you don't have to waste a lot of time trying out ones that just don't look good for a particular image. *Note:* The number you see displayed on each preset tile is the number of presets available under that category (for example, the Creative tile has an "8," and there are eight presets to choose from in its pop-up menu). *Note:* If you're wondering if you can create a preset in Lightroom on your computer and bring it over here into Lightroom on your mobile device, be sure to check out page 79.

Adjusting Presets

Here, I tapped on the Color tile and chose Cool as my preset, but when I looked at the result, I wanted it a little brighter. Luckily, again, you can edit things like exposure and shadows after applying a preset, so tap on the Edit icon to return to the adjustment tiles. Here, I tapped on Shadows to bring up the slider, and I tapped-and-dragged over to +51 to really open up those shadow areas. Keep in mind that if you chose the Split Tone preset, you could also change the balance or intensity or hue of the colors in the split-tone color effect (choose Split Toning in the Adjust pop-up menu, at the right end of the adjustment tiles), as well as tweak individual areas of your image if you chose a B&W preset or adjust a Vignette preset setting (also by choosing these adjustments in the Adjust pop-up menu).

Applying More Than One Preset

In some cases, you can "stack" presets—having one add its effect on top of another—and a great place to see this in action is when you use the Effect presets, which add things like vignette looks (darkening the outside edges of your image) or noise (grain) or a blur vignette. The reason these add on is that they don't use the Split Toning panel or the HSL panel or any other options that might get changed by applying another preset. For example, if you apply a B&W preset, then apply a Color preset, the color overrides the black and white and changes the image back to color. But, adding noise (grain) or a vignette adds on to the look you applied with the first preset. Here, I started by applying the B&W preset, Film 2. Then, in the overlay shown here, I tapped on the Effect presets and added Grain (Heavy) to enhance the grainy film look.

Copying-and-Pasting Settings from One Image to Another

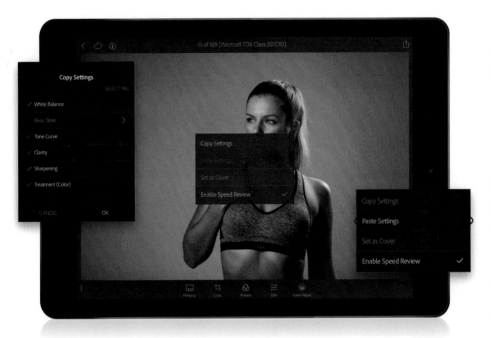

We do this all the time in Lightroom on our computers (well, even if you don't, you at least you know you can), and now that same feature is in Lightroom on your mobile device. Here's how it works: In Loupe view, tap-and-hold on the photo that has the settings you want to copy. When the pop-up menu appears, tap on **Copy Settings**. This brings up the menu you see here in the overlay on the left and, by default, it's going to copy all the settings from this image. But, if there are certain settings you don't want copied, tap on them to deselect them, so it only copies the ones you want. Tap OK, then swipe over to any image you want to have these copied settings applied to, tap-and-hold on the that image, and when the pop-up menu appears, choose **Paste Settings** (as seen in the overlay on the right), and you're done.

Copying-and-Pasting Features That Aren't in Lightroom Mobile

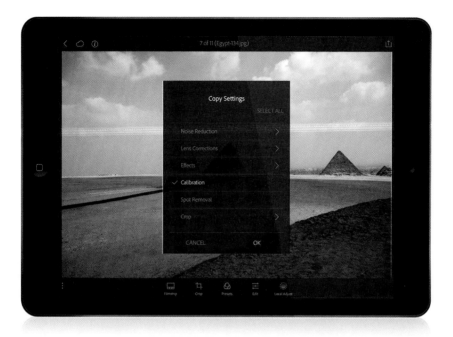

This is pretty slick, because it allows you to do something you shouldn't be able to do in Lightroom on your mobile device, and that's because Lightroom on your mobile device doesn't have all the features that Lightroom on your desktop has. For example, there's no Camera Calibration. However, if you bring an image over to Lightroom on your mobile device that already has stuff like that applied, you can copy-and-paste those settings over to another image inside of Lightroom on your mobile device. Here's how: When you choose Copy Settings on an image that has had some of those features from Lightroom on your computer added (that Lightroom on your mobile device doesn't have), when the Copy Settings pop-up menu appears, keep scrolling down (here, I made some Camera Calibration adjustments to this image, so I scrolled down and tapped on Calibration, and then tapped to turn off everything but that adjustment). You can now copy those edits from that photo into memory, and then you can paste them into another image right in Lightroom on your mobile device. I know. Pretty sweet, right?

Making Collections of Adjustments Not in Lightroom Mobile

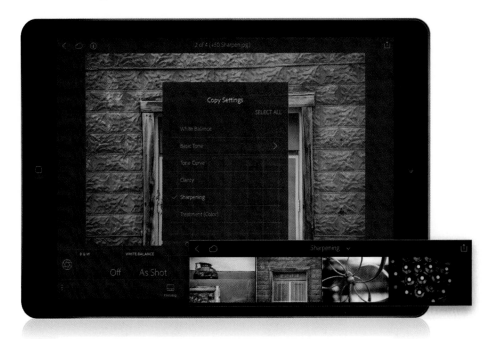

Now that you know you can copy-and-paste settings that were applied to an image in Lightroom on your desktop (but that aren't yet in Lightroom Mobile), why not create a collection of images with edits applied in Lightroom on your computer to sync with Lightroom on your mobile device? Stuff like sharpening, for example. It's not in Lightroom Mobile, but you can use this copy-and-paste trick to sharpen images there. Start in Lightroom on your desktop. Choose an image, apply some sharpening and remember the amount (let's say you applied an amount of +50). Put that image in a collection named "Sharpening" and rename the photo "+50 Sharpen." Choose another image, apply a sharpening amount of +75, and repeat that process. Do an amount of +25, and then do an amount of +100. Now, you can sync this Sharpening collection to Lightroom Mobile and copy-and-paste the sharpening from these photos onto any other photos in Lightroom Mobile. Sweet!

Making a Collection for Third-Party Presets

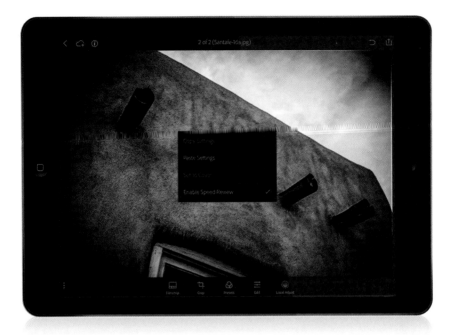

Okay, let's take the copy-and-paste idea we just looked at on the previous page a step further. Instead of just copying-and-pasting individual adjustments, like sharpening or camera calibration settings, why not do something that everybody has been dying to do—use third-party downloadable Lightroom presets in Lightroom Mobile. Of course, you can't normally do that, right? Right. But, by using this copy-and-paste scenario, you can. Here's what you do: Start in Lightroom on your desktop and open an image with no edits applied to it yet. Apply a third-party preset (maybe one you downloaded from the web or one that comes with my *The Adobe Photoshop Lightroom CC Book for Digital Photographers*) to that untouched image, and then rename that image with the name of the preset (click on the photo in Grid view, go under the Library menu up top, and choose Rename Photo). Repeat that for as many third-party presets as you want to use in Lightroom Mobile, and then put all those images in a collection named "Third-Party Presets." Sync that collection over to Lightroom Mobile, and now you can just copy all the settings from one of these Third-Party Preset images and paste them onto any other image in Lightroom Mobile (as I did here, where I applied an ultra-gritty effect preset). There ya have it—you just did the undoable. :) (*Note:* Keep in mind that you probably won't be able to make many adjustments to these presets. Just so you know.)

SHUTTER SPEED: 1/1000 sec | F-STOP: F/4 | ISO: 200 | FOCAL LENGTH: 560mm | LOCATION: Tampa, FL, Buccaneers vs. Falcons

Chapter Five

Cropping and Stuff Like Cropping
Hey, Rotating Is Like Cropping, Right?

How important is cropping? Well, to give you an idea, a few years back, Adobe took the time to go back and do a bunch of updates to Photoshop's Crop feature, noting that the #1 most-used tool or feature in all of Photoshop was cropping. So, I guess it's pretty important. Of course, cropping is available in Lightroom Mobile, but before you go off on a cropfest, I think it's important that you know, from a historical perspective, where the term "crop" came from, because it's an interesting story (and one that is seldom shared). The term "CROP" was originally thought to be an acronym for "Careful Realignment Of Photo," but in the late 1970s, photography researchers at the University of Illinois at Urbana–Champaign uncovered the original roots of the term, which as it turns out was actually named after famous Portuguese still-life photographer Carlos Remedios Ovidio Perez, who often cropped his photos using a wild "tesoura" technique. Word of his cropping became known throughout the Latin photography world, where he earned the nickname "Carlos El Cropadero!" which roughly translates to "Carlos the lone cowboy who crops like Senór John Wayne." Now you know… the rest of the story.

Cropping an Image

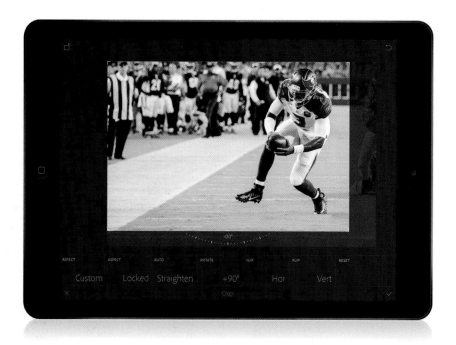

If you need to crop an image, tap on an image to open it in Loupe view, and then tap on the Crop icon in the Action options at the bottom of the screen, which activates the Cropping tool. You'll know it's active because it puts a cropping border around your entire image (as seen here), and the tiles along the bottom contain one-click cropping aspect ratios (1x1, 5x4, and so on) and some other options for transforming and adjusting the image. To crop the image, just tap on a side or corner handle and drag the cropping border where you want it. The areas that will be cropped away are still visible, but they're shown in dark gray (you can see here the players on the right would be cropped off if I were to go with this crop). To return to the original uncropped image, just double-tap anywhere within the cropping border or tap on the Undo icon (the curved arrow) at the top right. To commit the crop, tap on the checkmark icon at the bottom right or to get out of Crop altogether, tap on the little X icon at the bottom left.

Applying Preset Cropping Ratios

If you know you want a particular size ratio for your image, tap on the first Aspect tile and a pop-up menu appears with a list of preset sizes. Tap on the ratio you want applied (here, I tapped on 4x3), and the cropping border updates to the new ratio. Now that you've applied a crop, you can reposition your image within that cropping border by just tapping-and-dragging the image right where you want it.

Free-Form Cropping

If you tap on the second Aspect tile, it changes from Locked to Free. Choosing this means you're not constrained to any preset ratio. So, once you choose it, you can then tap on any corner or side of the cropping border and move just that part right where you want, without affecting the other three sides (it's like clicking on the Unlock icon for the Crop Overlay tool in Lightroom on your computer). Here, I tapped on Free and then just tapped-and-dragged each side of the cropping border right where I wanted it.

Straightening an Image

The photo shown here has a crooked horizon line, which pretty much ruins a great landscape shot. If you have a crooked image, to have Lightroom Mobile automatically straighten it, tap on the image to open it in Loupe view, and then tap on the Crop icon in the Action options at the bottom of the screen, which activates the cropping border. Now, just tap on the Auto Straighten tile and it will analyze the image for a few seconds and then automatically rotate it to where the image is straight.

Manually Rotate an Image

If you want to manually rotate your image within the cropping border, just tap-and-hold outside the cropping border and drag up/down, and the image will rotate within the cropping border (so you're rotating the image, not the border). You can also tap-and-drag the Cropping Wheel that appears beneath the image. While rotating, you'll see a grid appear over your image (seen here) to help you with the rotation. Here, I tapped on the second Aspect tile, selected Free (so I could move any side of the border), and then I tapped-and-dragged outside the border to rotate it until it was straight.

Rotating an Image 90°

If you want to rotate an image 90°, tap on the Rotate tile. Each time you tap it, it rotates the image 90°. *Note:* On an iPhone or Android phone, to save space, the Rotate tile is combined into a single Orientation tile, and when you tap on it, a pop-up menu appears where you can choose to rotate 90° (or Flip Horizontal or Flip Vertical; more on this in a moment).

Flipping an Image

If you want to flip an image horizontally, tap on the Flip Hor tile, and it flips your image (like I did here). Of course, tapping on the Flip Vert tile flips your image upside down. *Note:* On an iPhone or Android Phone, to save space, the Flip tiles are combined into one single Orientation tile, and when you tap on it, a pop-up menu appears where you can choose Flip Horizontal or Flip Vertical (or rotate 90°, which we just looked at).

Flipping the Crop to Tall

By default, a crop is applied wide (landscape), but if you want to flip it to the same ratio, but tall (portrait), just tap on the Rotate Photo icon at the top left of the screen (circled here in red).

SHUTTER SPEED: 1/6 sec | F-STOP: f/71 | ISO: 200 | FOCAL LENGTH: 24mm | LOCATION: State Theatre, Sydney, Australia

Chapter Six

Sharing Your Images

How to Share Your Work with the World (or Just Your Sister. It's Your Call)

Back in the "old days," the only way your image was going to been seen by more than your family, and the neighbors on either side of your house, was to somehow get "published" in a magazine or newspaper. However, that was just about impossible for most photographers because the periodicals were tightly controlled by a cartel of powerful photo editors, whose main delight in life was to send potential contributors a tersely worded letter letting them know, in no uncertain terms, that not only was their photo submission rejected by the publication, but that they should be embarrassed beyond measure to think that anyone, on any continent, would ever even consider publishing their work in any form. And, that the only thing left for them to do was to not only sell all of their equipment immediately, but to then track down the original sales clerk at the camera store who sold them this gear and admonish that clerk thoroughly for letting them even buy a camera in the first place, which was clearly the clerk's lapse in judgement. I'm happy to say that today, things have changed, and now all those very same photo editors have become full-time parking attendants at the Westfield Garden State Plaza Mall in Paramus, New Jersey. True story.

Sharing an Image

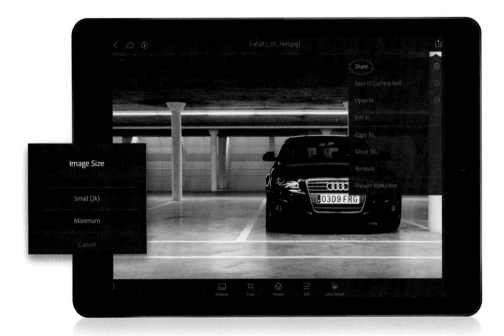

When you're looking at an image in Loupe view, tap on the Collection Options icon in the top-right corner of the screen (the one with the arrow pointing up). At the top of the resulting pop-up menu, tap on **Share**, which brings up another pop-up menu with Image Size options (seen in the overlay here). Tap on your choice, and it'll prepare the photo, and then a bunch of sharing options (depending on which device you're on and which apps you have downloaded) will appear, which can range from emailing them, to texting, to sharing to Facebook, to saving them to your device. If you want to share multiple images from a collection, when viewing the collection, tap on the Collection Options icon, tap Share, then tap on the photos you want to share to select them (if they're contiguous, you can just tap-and-drag across them). Once they're selected, tap on the checkmark icon in the top-right corner, the Image Size dialog will appear, and then you'll see the pop-up menu of sharing options after you make your choice.

Sharing a Collection

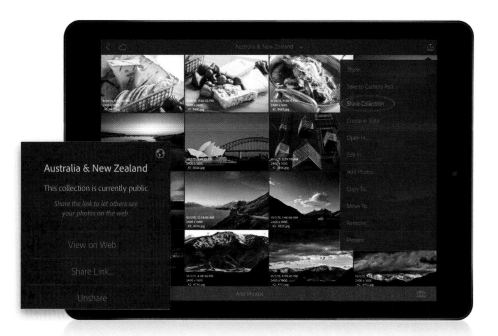

If you want to share an entire collection, you can do it by having Lightroom create a webpage for that collection, which you can then send a link to, to anyone you'd like (or even share it publicly on Facebook or Twitter). To do this, while looking at a collection, tap on the Collection Options icon in the top-right corner of the screen, then tap on **Share Collection**. This brings up a dialog where you first tap on Share to make it public, and then you can choose to jump to the webpage that has been created (so you can see it yourself first), or you can just share it via email, text message, etc. You can also stop sharing any collection the same way—when the dialog appears, tap Unshare, and it makes that collection private again.

Opening an Image in Another App

While viewing an image in Loupe view (or a collection in Grid view), if you choose **Open In** or **Edit In** from the Collection Options pop-up menu (tap on the icon with the arrow pointing up in the top-right corner of the screen), you can open the selected image in another app on your mobile device. When you do this, the first thing it asks is how large a file (resolution-wise) you want to send over to this external app—it'll ask Small size or Maximum size (I always choose Maximum, unless I'm just experimenting). After you make your choice, it'll prepare the image, and then another pop-up menu will appear with app options for you to open the image in. For example, if you have Adobe's awesome Photoshop Fix app (shown here; it rocks and it's free), you can take your image over there for things like removing spots or blemishes, or making some Liquify adjustments, and then the edited image comes right back to Lightroom Mobile automatically when you're done. Which apps you can jump over to depend, of course, on which apps you already have installed on your phone or tablet. But, again, when you choose Open In or Edit In, after you make your Image Size choice, you'll be presented with a list of apps you already have installed, so you'll quickly see what your options are.

Share or Open with Metadata. Or Not

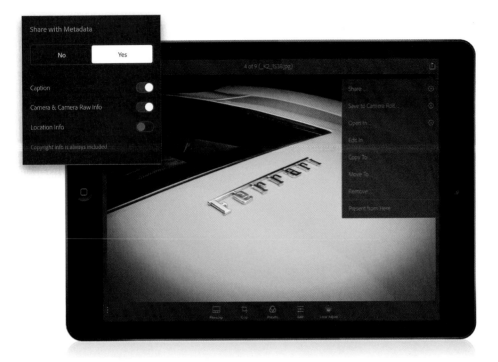

If you choose to share an image, or open it in another app (and that app supports metadata), you can choose to include (or not include) the metadata by tapping on the little gear icon to the right of the menu option. The Sidebar will pop out from the left, and here you can choose whether or not to share or open the image with metadata. If you're opening multiple images in a collection in another app, or sharing them, you'll find the gear icon in the top right of the Open In/Share screen (to the left of the checkmark icon) where you're selecting which images to open/share. Tap on it there, and then make your Share with Metadata choice.

Create in Spark Page

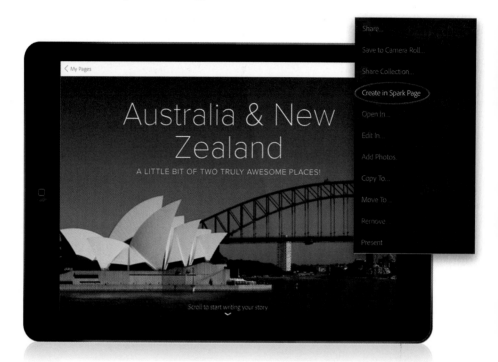

Another way to share your images, with detailed text if you like, is to share a collection through Adobe's Spark, which is a free app that, among other things, lets you create very rich, immersive stories online using words and images (this used to be named "Adobe Slate," and you may have seen one or more stories I published there after taking a photo trip). It allows you, through the app, to create image stories, with a bit of motion, that makes communicating an idea or story really visual and fun. To share your collection as a Spark story, open the collection, tap on the Collection Options icon in the top-right corner of the screen (the one with the arrow pointing up), and then tap on **Create in Spark Page**. (*Note:* This is currently only available on the iPad.) It will then launch Adobe Spark (you'll have to download the free app, if you don't already have it, and you'll have to log in with your Adobe ID so that it syncs your collections), where you'll choose a template, start adding your text, reorder your images, and then share your story online (there are tutorials on Adobe's website to help you learn Spark. Luckily, it uses professionally designed layout templates, so creating a Spark story is pretty simple).

Saving to Camera Roll (or Gallery)

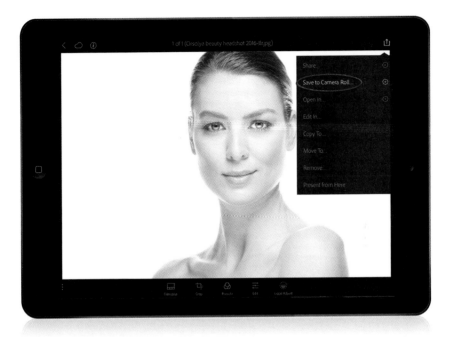

If you edit an image in Lightroom Mobile, you can save a high-resolution version of that edited image to your phone's or tablet's Camera Roll (or Gallery on an Android device). When you're done with your edits, tap on the Collection Options icon in the top-right corner of the screen (the one with the arrow pointing up), then tap on **Save to Camera Roll** (**Save to Gallery** on an Android), and you're done.

View Images in Presentation Mode

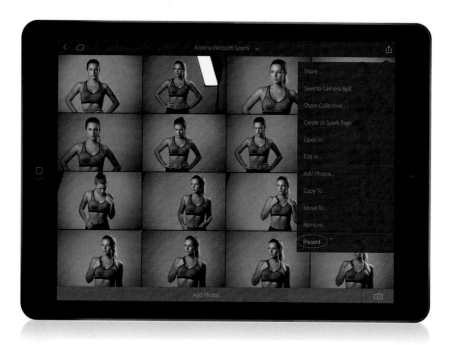

We looked at this a bit when we talked about slide shows in Chapter 2, but this is important to know: If you want to hand someone your mobile device and let them swipe through your images in Lightroom, there's always the chance that they might swipe up/down and change a star rating or a Pick flag for an image, or maybe they'll accidentally tap on the icon that takes them to the adjustment tiles (ack!). That's why Presentation mode was invented—it disables all that stuff, so you don't have to worry about them accidentally changing anything. You enter Presentation mode by tapping on the collection you want, then tapping on the Collection Options icon in the top-right corner, and choosing **Present** (**Slideshow** on an Android) from the pop-up menu. When they hand your mobile device back to you, just tap the X in the upper-left corner to exit Presentation mode.

Viewing Images on Apple TV

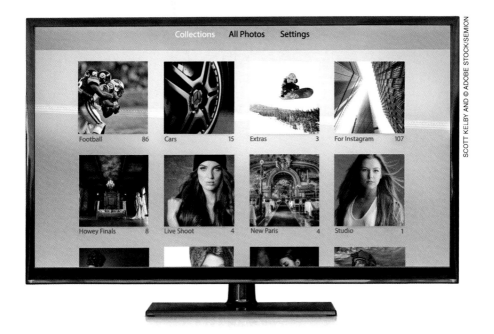

Start by going to your Apple TV, clicking on the App Store icon, searching for the free Lightroom app in the App Store, and then downloading it. It will now appear in your main Apple TV menu, right along with your other apps, like Hulu and HBO NOW and Crunchyroll. It will ask you to jump through some security hoops while connecting to your lightroom.adobe .com account (just follow the onscreen prompts—it's easy). Once you're connected, it will automatically display your synced collections, or at the top of the screen, you can click on All Photos to see all your images. To view a collection, move the Apple TV remote over the collection, click on it, and it shows the images inside that collection. If you click on an image, it puts the image in Loupe view. To zoom in, click on the photo. To zoom out, press the Menu button on your Apple TV remote (the Menu button acts like a Back button, so to get back to all your collections, you'd hit the Menu button on your remote again). If you scroll down with the remote, it brings up a filmstrip across the top of the screen, so you can jump directly to any image in a collection. You can also use the remote to swipe through your images, forward or backward. To see a slide show of the images in a collection, click the Play button on your Apple TV remote.

Chapter Seven

Sharing Your Shoot Live

Yes, You Can Share Your Shoot Live
with Anyone, Anywhere, Anytime

So, why is it so important to us that others, including strangers we don't even know, share our every thought, our every meal, and our every experience through social media? I'll tell you why (and I may be the first person to accurately describe this psychological state in which seemingly random people are invited into your life on a daily basis to see what you're having for breakfast). Of course, this isn't reality because now what you're having for breakfast has been altered by the fact that via Twitter and Facebook Live streaming, and Periscope, people from all over the world, who have so little to do that they're going to tune in to watch what you're having for breakfast, will now cast judgement on said breakfast. So, you can't really have what you actually want for breakfast, which is Kellogg's Honey Smacks, which gets a staggering 60% of its calories from sugar and has something like 128 carbs per spoonful. And, worse yet, you want some Pop-Tarts, too. And, a stack of bacon that is only eclipsed by a stack of pancakes that are approximately the size of a car battery. Yes, that's the real breakfast you want, but nooooo, you're sharing your breakfast on social media. So, instead, you eat steel-cut oats and Greek yogurt, and before I run out of space, here is the real reason why people share their every waking experience all day long on their social media channels, and it's all simply because....

Shoot Tethered

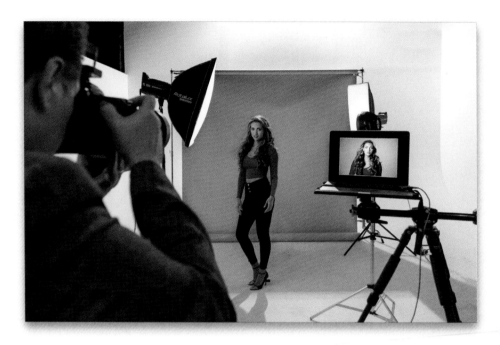

When I'm shooting in the studio (or even on location, if possible), I shoot tethered directly into Lightroom on my laptop, so my images go directly from my camera straight into Lightroom. Here's a behind-the-scenes shot from a studio shoot. As I shoot the images, they go straight into Lightroom on my laptop, as seen here.

Set Up Your Tethered Shoot

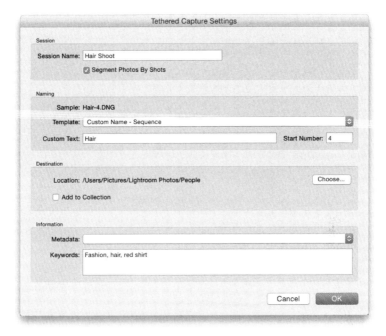

To get started, go to Lightroom on your desktop, go under the File menu, under Tethered Capture, and choose **Start Tethered Capture**. This brings up the dialog you see here, where you enter pretty much the same info as you would in Lightroom's Import window (you type in the name of your shoot at the top in the Session Name field, and you choose whether you want the images to have a custom name or not. You also choose where on your hard drive you want these images saved to, and if you want any metadata or keywords added).

Create a New Collection

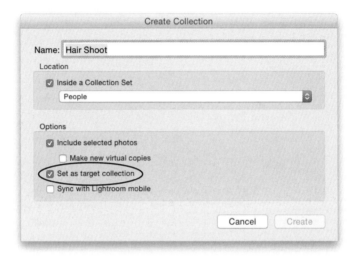

When you shoot tethered into Lightroom, the images come into a folder in Lightroom (which we just created on the previous page), but of course Lightroom on your mobile device only syncs collections, right? Of course, you could drag that entire folder into the Collections panel and sync that, but then my client would see every shot—ones where the model's eyes are closed, ones where the light didn't fire, ones where my composition was off, and well... they'd just see lots of lame shots. I only want my client seeing good solid shots, not those that should be deleted. So, here's what I do: First, create a new collection in Lightroom on your computer by clicking on the + (plus sign) button on the right side of the Collections panel's header and choosing **Create Collection** from the pop-up menu. When the Create Collection dialog appears, give it a name (I named mine "Hair Shoot"), then turn on the Set as Target Collection checkbox (a very important checkbox for this workflow to work).

Sync Your New Collection

Go to the little gray Sync checkbox to the left of this new collection and click on it to turn on syncing for this collection. You'll see a message appear onscreen for a second or two letting you know that this collection will be synced with Lightroom on your mobile device, as seen here. (*Note:* You can also turn on the Sync with Lightroom Mobile checkbox in the Create Collection dialog [see previous page], if you know for sure you're going to sync the collection when you create it.) Now that everything's set up and ready to go, I launch Lightroom on my iPad, open the new Hair Shoot collection, and hand the iPad to my client, or Art Director (a friend, an assistant, a guest on the set, etc.), who is there on the set well behind where I'm shooting from (most photographers don't like someone looking over their shoulder when they're trying to shoot).

Send Images to Your Target Collection

So, here are the shots coming in to Lightroom on my laptop from the shoot. Check out that fourth shot where her hair is in her face—why would I want my client to see that? Or the fifth frame where the model is mid-pose. But, when I see an image come in that I like, I just press the letter **B** on my keyboard and that image is sent to my iPad, and the client sees that image a few seconds later. The reason this works is because when I press B, that image is sent to the Hair Shoot collection (remember, I made that my target collection when I created it? Making it a target collection means that any time I hit the letter B for a selected image, that image goes to that collection I've targeted), and that collection is synced to Lightroom on my iPad, so my client sees only the images I hit the letter B on. How cool is that? So, that's my process: hit B on good shots, and the client sees just those keepers. But, we're just getting started (this gets even better).

What Your Client Sees

Here's a look at the iPad my client is holding, and instead of there being 100 or 200 images flowing in there, it's just the images I hit the letter B on. Just the images that I want my client to see.

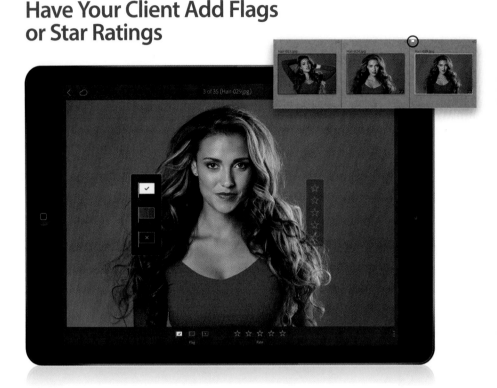

Have Your Client Add Flags or Star Ratings

Now, when I hand the client the iPad, I show them how to swipe up to flag an image as a Pick and how to swipe down if they change their mind. I also let them know that they can just tap the Pick flag at the bottom of the screen (when I give them the iPad, I tap on the three dots, on the left side of the Action options, and drag to the right so the Flag and Rate options appear there, instead of the adjustment tiles), or they can tap on a Star icon—once for each star they want the image to have (I tell them to only add a star rating to one that really stands out to them—one of their very favorites—and the rest that they like just mark them as a Pick). Since we're synced, when they choose a photo to get a Pick flag or star rating, those get sent back to my collection (as seen in the overlay above), so I can instantly see which ones they like (and which to try to do more of). So, your client is seeing your images appear on the iPad they're holding. What if you could also share this same collection with someone else who's not even there? Maybe they're back at the office, or out of town, or even out of the country? Well, not only can they follow along with your shoot, they can be a part of it.

Make Your Collection Public

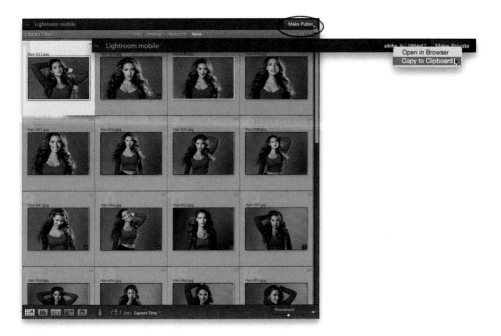

In Lightroom on your computer, at the top of the Preview area in Grid view, on the right, you'll see the Make Public button. If you click on that button, it generates a URL (web address) that, at this point, only you have access to (even though the button says "Make Public"), and that you can now email or text to someone anywhere in the world, so they can follow along—and see the same images your client is seeing on your iPad—and they can do this all right from any web browser. They don't need an Adobe ID. They don't need special software—just Internet access and a web browser. It'll list a URL just to the left of the Make Public button (which, after you click, changes to Make Private, if you want to turn off access to the person you sent it to, as seen in the overlay) that you can Right-click on to copy-and-paste to your client. By the way, you can send that URL to more than just one person, so multiple people in different locations can see.

Note: Only people you send the web link to will be able to see your shoot images in their web browser, even though the button says "Make Public." A better name for that button might be "Invite." Just sayin'.

What Your Offsite Client Sees

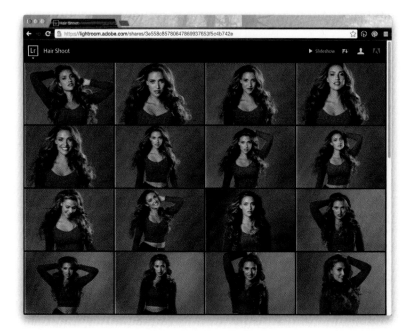

When the offsite person goes to that URL you sent them, they see what you see here: the same images the client right beside you there in the studio is seeing. If they hit the Play icon, to the left of Slideshow, in the upper-right corner, they'll get a slide show of the images in your Hair Shoot collection. If they want to change the sort order, they can click on the Sort Order icon to the right of Slideshow (if they hover their mouse over any of the icons, a little pop-up explains what they do, so you don't have to give them a demo). So, at this point, yes, they can see the images, but they're not really "part of the shoot," right? Well, it's about to get even better (though, they will need to sign in with an Adobe ID in order to use some of the features we'll look at next).

Favorites Made Offsite

If the offsite person viewing through their web browser clicks on one of those thumbnails, it zooms in to the larger size you see here. Here, they can tag a photo they like as a Favorite by clicking on the little heart icon in the lower-left corner of the window (seen circled here; they need to use something different than a Pick flag, because your client there with you on the iPad is using Pick flags) after they sign in with their Adobe ID. Any image they tag in their web browser as a favorite is sent back to you, as well, to Lightroom on your laptop. But, they actually have a feature here in the web browser that the client with you doesn't even have in the iPad in their hands: the ability to send written comments directly to you.

Comments Made Offsite

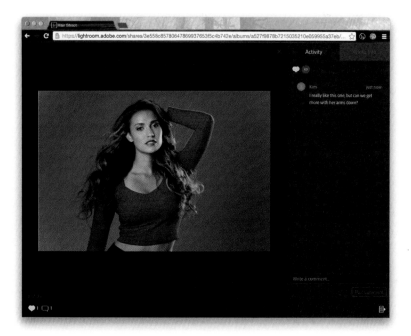

To send a comment on a photo, they just click on the Comment icon in the bottom-left corner of the window (or the Show Activity & Info icon in the bottom right), and an Activity sidebar slides out from the right side. They type in their comment (as seen here, where they wrote "I really like this one, but can we get more with her arms down?"). Once they hit the Post Comment button, that comment is sent directly to Lightroom on your computer (on my laptop, in this case) where not only can you see their comment, but you can even respond.

What You'll See in Lightroom

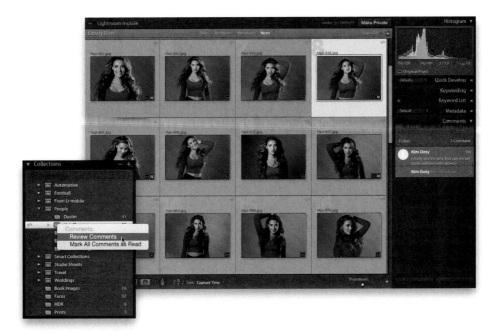

When you look in Lightroom on your computer, you'll know if the offsite person commented or "Liked" a photo because you'll see a little yellow comment icon on your synced collection in the Collections panel. You'll also see yellow comment/favorite badges in the bottom-right corners of the thumbnails for images that were marked as favorites or commented on. Your client with the iPad will also know because they'll see a little comment icon appear at the top right of the collection's screen. If they tap on it, they'll see a pop-up menu with all the images marked as favorites and commented on. If you click directly on that yellow icon on your collection, you can choose to Review Comments now (as shown in the overlay here), or to ignore them by choosing Mark All Comments as Read. To read them, look in the Comments panel at the bottom of the right side Panels area in the Library module. Now, once you've looked at all the images with a comment/favorite badge, the yellow comment icon goes away on your collection, and the badges on the thumbnails turn gray. So, what I do is select all of those images with comments and create a new collection, and either put it in the same collection set as this collection (if I made one for it), or I just give this new collection a very similar name (like "Hair Shoot Comments"), so it appears right next to it alphabetically in the Collections panel. That's it!

SHUTTER SPEED: 1/320 sec | F-STOP: f/8 | ISO: 200 | FOCAL LENGTH: 28mm | LOCATION: Ross Castle, County Kerry, Ireland

Chapter Eight

Using the Built-In Camera

It's Way Better Than You'd Think

I know you're probably thinking, "Hey, I want to use Lightroom Mobile to extend the power of Lightroom on my desktop, and I want to use this for my serious DSLR images or my mirrorless camera images." But, did you know you can also take pictures with the crappy camera built right into your smartphone, and not only that, but Lightroom Mobile has its own built-in camera that makes your phone's built-in camera slightly less crappy? That's right, it's a decrapilator. Okay, to be fair, not every smartphone's camera is crappy—as long as you're shooting in nice bright light (which happens around 1/2 the day), the shots come out pretty nice, but as soon as you get in a low-light situation, they turn…well… crappy. And, by crappy, I mean you get the amount of noise you'd expect from an NHRA dragster—it looks like you took the shot in the snow. That level of crappy (*side note:* I never intended to use the word "crap" as often as I did. It just came flowing out of me. So, I asked my editor [we'll call her "Kim" because that's her name] to replace all instances of the word "crap" with either the word "rainbow," "puppies," or "unicorn," but I can't swear that she actually did that, because the last time I saw her, she was really pooped. She was waiting for the movie *Constipated* to come out, but it still hadn't been released). I can do this all day, folks. It's a gift.

Accessing the Camera

Lightroom Mobile's built-in camera is surprisingly good. It offers lots of control, built-in live filters, and your images not only go straight into Lightroom on your mobile device, but they also sync back into Lightroom on your desktop. To access Lightroom Mobile's camera, when you're in Collections view, or in a collection, just tap on the camera icon at the bottom-right corner of the screen, and you're ready to go. To manually focus the camera, tap anywhere on the screen and a white box appears onscreen (as seen here) focusing on that area. (*Note:* Currently, Lightroom's built-in camera is not available on Android tablets, but it is available on Android phones.)

Using the Camera Features

There is a row of icons at the bottom of the preview image area, or on the side, if you're hold-
ing your iPad or phone sideways (as seen here). The first icon on the left/top lets you choose
your camera's flash options—Auto, On, Off, the usual stuff. The second icon from the left/top
(the AWB icon) is awesome because it lets you choose your white balance live, which means
you can try out different ones even before you take the shot, so you can get the color right
from the very start. You can even set a custom white balance (see page 120). If you tap on the
third icon directly above/next to the shutter button, it lets you use Exposure Compensation
to brighten or darken the image—just tap on the slider that appears (as seen here) and drag
to the left/up to brighten the image or to the right/down to darken it. The fourth icon (the one
that looks like a pound sign) lets you bring a rule-of-thirds overlay grid up over your preview
area, a square preview border, or a horizon finder level feature, so you can make sure your
image is level when you take it (when you choose this one, the horizontal line in the center
of the image will tilt until you're holding the camera perfectly straight—then it becomes a
straight solid line). The last icon on the right/bottom is a built-in self-timer. Tap on it and you
can then set the self-timer to 2, 5, or 10 seconds. To the right of the shutter button (or below)
is the Presets icon (it has three overlapping circles). See page 122 for more on these live filters.

Shooting RAW Images with Android Camera Phones

SCOTT KELBY AND PHONE MOCKUP ©DANIEL BOLYHOS

Okay, it's not all Android phones, but there are certain Android models (ones that support the Camera2 API, which was introduced in Android 5.0 Lollipop, like the Samsung Galaxy S7 or the LG G4) that actually can shoot images in the RAW DNG format. If you have one of these phones (it's a hardware thing—not a software one), you can also edit these RAW images directly in Lightroom Mobile for Android. Just import them into Lightroom from your Gallery and you're off to the races. By the way, if your Android smartphone shoots in RAW format, you can use Lightroom's built-in camera to shoot those RAW images directly (as well as shoot in Pro mode, where you can set your shutter speed, ISO, white balance, and focus. You'll know if you can shoot in RAW if you tap on the onscreen file format badge and it lets you choose Raw, as seen circled here).

Previewing Your Last Capture

Once you take a photo with Lightroom Mobile's built-in camera, if you want to take a look at the shot you just took, and you're on an iPhone, just tap-and-hold on the little square thumbnail just to the left of the shutter button and a large preview of the image will appear onscreen (as seen on the right). When you release your finger, it shrinks back down to that small thumbnail size. If you're using an Android phone, just tap on the little thumbnail to get a larger preview, and then just tap on the preview when you're done.

Setting a Custom White Balance

To set a custom white balance for your camera (a white balance that is custom-tuned to the current lighting conditions), tap on the AWB (Average White Band… um…I mean, Automatic White Balance) icon (on some Android camera phones, in Pro mode, tap on the WB icon), and then tap on the last icon on the right (it looks like a wrench). This brings up a rectangle asking you to point the camera at something neutral and fill that rectangle with that area (ideally, this would be something light gray, but of course, there's not always something light gray just hanging around when you need it. So, if there's not, try to focus on something that's neutral. Something that's an even color, like tan). Tap on the shutter button (you'll see it has a checkmark icon on the button now) to lock that neutral area in as your custom white balance, and you're ready to shoot.

iPhone Users: Get to Lightroom's Camera Faster

If you have an iPhone 6s or later, use the 3D Touch feature: just press-and-hold on the Light-room app icon and a Take Photo button will appear (seen above left). Tap it, and you're using Lightroom Mobile's camera. If you don't have an iPhone 6s or later, then you'll want to set up your iPhone so you can access Lightroom's built-in camera directly from the Notifications screen, rather than having to launch Lightroom every time just to get to the camera. Here's how: Swipe down from the top of the screen to access your Notifications screen, tap on the Today tab at the top, and then scroll to the very bottom and tap the Edit button. Scroll down again until you see Lightroom, then tap on the green + (plus sign) to the left of Lightroom to add it to the "Include" list near the top. Now, in the top section, tap to the far right of Lightroom and drag it up higher in the list, then tap on the Done button. Okay, that's the setup (it's a little tedious, right? But it's done). Now, here's how to access Lightroom's camera quickly anytime without having to launch Lightroom: Whenever you want it, just swipe down from the top of the screen to bring up the Notifications screen and, right near the top, you'll see Lightroom Mobile and directly below it a camera icon that reads "Take Photo" (as seen above right). Tap on that, and you're using Lightroom's camera. It's much more accessible than it sounds (it's just two taps now: swipe down, tap Take Photo).

Using Live Shooting Presets

When you're in Lightroom Mobile's camera, you can apply live filters while you're shooting (so you'll see the effects as you shoot, rather than applying them after the fact). To access these live filters, tap on the Presets icon (the one with the three overlapping circles to the right of the shutter button). This brings up six small previews of your image with different shoot-through filters applied, from a contrasty look, a warm shadows look, all the way to a contrasty black-and-white filter, to a really flat-looking black and white (it looks kind of "Instagrammy"). If you want to use one of those, tap on the preview you want, and now you're shooting live with that filter. To remove all the filters, tap on the first one (the one on the far left or bottom). Extra cool thing: if you do apply a filter preset, you're basically just applying a Lightroom preset to your image, which means it's totally undoable anytime, so you're not locked into that filter you chose when you shot it (see page 72 for more on presets). (*Note:* For Android phones, these live shooting presets are currently only available for models that support Open GL ES 3.0 or later. You can find the version supported for your Android phone in Lightroom Mobile's Sidebar.)

Finding the Shots You Just Took

The images you take with Lightroom Mobile's built-in camera are automatically saved into your Lightroom Photos collection, and you can jump right there by tapping on the left-facing arrow up in the top-left (or bottom-left) corner. These images will also automatically sync back to Lightroom on your desktop after you add them to a collection. They'll then appear within that collection in your From LR Mobile folder on your desktop.

Chapter Nine
All the Other Stuff
This Stuff Needs a Home, Too

Doesn't the phrase "other stuff" seem really casual for a book about a new emerging technology like Lightroom Mobile? Yes, yes it does. But, what would you call a chapter about all the other stuff that you know should be included in the book but doesn't really fall into any of the previous chapters, which are all dedicated to major categories or features within Lightroom Mobile? Well, I'll tell ya—you call it "Other Stuff," and you move on with your life, because in the grand scheme of things, there are bigger fish to fry in our complex world than what some photography author names his last chapter. By the way, this is one of the only books I've ever written with just nine chapters. But, in this case, it was very intentional, and that's because of the Trans-Pacific Partnership free trade agreement—if I keep my book at nine chapters or less, I can trade printed copies of it for safe passage on a steamship headed for Asia, and once I'm there, I can trade with local ranchers for my own herd of sheep, which I would then, of course, shear to make woolly coats that I can then wear around the local village as I shout, "Hey, check out my warm woolly coat, suckas!" But, of course, then they'll all throw packages of expired soft cheese down at me, causing me to stumble and perhaps even fall into a pile of Camembert, possibly breaking my hip in the process, and then I'm lying there with at least a fracture and the villagers are booing and hissing, and then it begins to rain. You see, this is why we can't have nice things.

Applying Your Copyright Info Automatically

To have your copyright info automatically embedded into your images as you import them into Lightroom Mobile, start by going to Collections view (kind of your main starting place where all your collections are), and then tap on the LR icon in the top-left corner of the screen to slide out the Sidebar. Now, toward the bottom, tap on Import to bring up the Import options, and under Metadata, tap on Add Copyright to turn on this feature. This will make the field below active, and you can then type in your copyright info (like "Copyright Scott Kelby, 2017—All rights reserved," as seen here). That's it. Now when you import images into Lightroom Mobile, it will embed this copyright into the image's metadata.

Using Keyboard Shortcuts

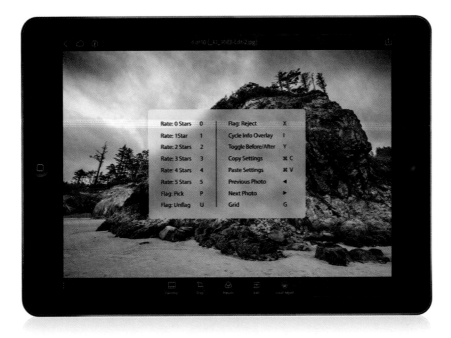

If you've attached a physical keyboard to your tablet or it's built into the case you have, you can actually use some of the same keyboard shortcuts from the desktop version of Lightroom, here in Lightroom Mobile. (*Note:* This is currently only available on an iPad.) Just press-and-hold the Command key on your keyboard and a little pop-up menu will appear with a list of shortcuts you can use. Just remember, this only works with a physical keyboard, not a pop-up software keyboard (I knew what you were thinking, right? ;-).

You Can Use It Without Using Lightroom on Your Computer

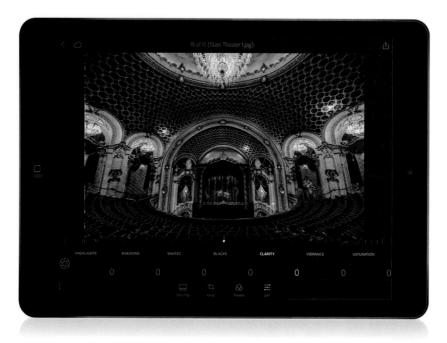

You don't have to sync your images and all that stuff. You can just use Lightroom on your mobile device to import and edit the images you took with your cell phone camera or your tablet camera—no matter how ridiculous it looks holding up a huge tablet to take photos (wait…who said that?!). So, basically, you can apply the editing power of Lightroom to images already on your mobile device (or what the rest of the world just calls their phone).

Finding Images That Aren't Syncing

If you're having problems syncing images between Lightroom on your desktop and Lightroom Mobile, here's what to do to see what the problem may be: Go to Preferences in Lightroom on your desktop (under the Lightroom [PC: Edit] menu), click on the Lightroom Mobile tab and, at the bottom of the dialog, you'll see the Pending Sync Activity section. Click on the little right-facing flippy arrow (the "disclosure triangle," if you will), and it will show you the current status of your sync. This is where you'll learn why certain files didn't make it over to Lightroom Mobile. For example, if it says "Master image missing" (as seen above), you'll know that you need to relink the thumbnail in Lightroom on your desktop to the original file (just click on the exclamation point icon in the top right of the thumbnail to find it), and then it will sync.

Moving Pop-Up Menus for Easier Editing

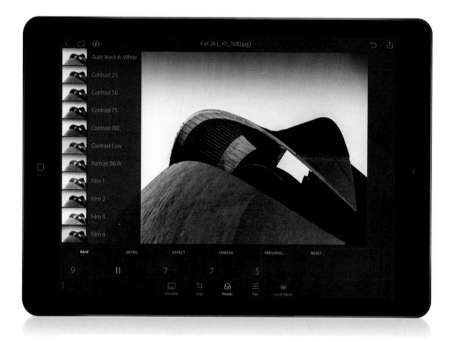

If you're editing in Lightroom Mobile, and you're using an edit feature with a pop-up menu (for example, let's say you're using the Presets and you tapped on the B&W preset tile), the menu winds up covering part of your image. Luckily, you can move that menu right out of the way. Just tap-and-hold on it and simply drag it to a new location on the left or right. When you're done with the menu, it resets back to its default position. Quick and easy.

The Benefits of Working Offline

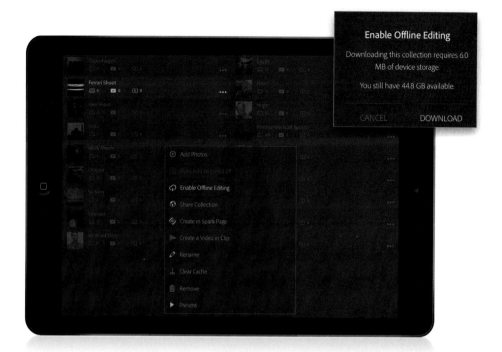

Let's say, for example, that you've synced some collections over to Lightroom Mobile (like your portfolio images or images that you're still working on), and you're going somewhere where you won't have an Internet connection (maybe on a plane or a train, at sea, out in the countryside, etc.). If you wanted to show someone your portfolio images or work on your editing, then you might consider taking some collections "offline," which downloads large previews onto your mobile device (instead of having Lightroom Mobile go to the cloud to pull the preview down. Not sure if you realized what happens, but what's actually stored on your mobile device are just the low-res thumbnails. When you start to edit an image, it uses your Internet connection to pull down a higher-resolution smart preview from the cloud, so you can edit it). If you go offline, you won't need an Internet connection to show them at full size or edit them. To do this, start in Collections view and tap on the three dots to the right of a collection's name. Then, from the pop-up menu that appears, tap on **Enable Offline Editing**, and it will download the higher-resolution previews for this collection while you still have an Internet connection (it also tells you how much space you have left on your mobile device [as seen in the overlay here], so you don't run out of space. But, luckily these smart previews are pretty small in size). Now you can share your portfolio or edit images...deep in the woods. *Note:* This whole offline thing only affects images you synced from Lightroom on your desktop. If you took photos with your mobile device and imported those into Lightroom Mobile, or you imported them from your camera directly, those files actually live on your mobile device, so they will always be available, online or offline.

Working with Video

You upload videos to Lightroom Mobile the same way you do photos—put the video(s) in a collection in Lightroom on your desktop and sync that collection. You can also import videos you shot with your camera or tablet's built-in camera by tapping on Camera Roll (Add Photos) at the bottom of the screen (if you don't see videos you know are in your Camera Roll [or Gallery], tap on the three dots at the top-right corner of the screen and then tap on Videos to turn on the feature that lets videos in the Camera Roll become visible to Lightroom Mobile), swiping on the video you want to import to select it, and then tapping Add 1 Photos at the bottom of the screen (yes, even though it's a video, and you may only have one selected, it still says Add 1 Photos). Since video files are generally much larger than still image files, you might have to wait a little longer for it to sync to Lightroom Mobile, if you added them from your desktop (if you're having sync issues, try keeping your Lightroom Mobile app open during the syncing process—don't switch to another app, letting it sync the video in the background. Keep it up front until the syncing is done, but again, that's only if you're not seeing the synced video appear in Lightroom Mobile). Once your videos are in Lightroom Mobile (your videos will have a little filmstrip icon in the top right of their thumbnails in Grid view), you can pretty much only preview them (all of the editing features in the Action options at the bottom of the screen are grayed out).

Turning a Collection Into a Video Automatically

You can take any collection and automatically transform it into a video using Adobe's Premiere Clip app (it's free), starting right within Lightroom Mobile. (*Note:* This feature is currently only available for iOS.) In Collections view, tap on the three dots to the right of the collection you want to turn into a video, then tap on **Create a Video in Clip** (if you haven't downloaded Premiere Clip yet, it takes you right to its App Store page). Once the app launches, and you sign in with your Adobe ID, it starts making your video. Not only is it creating your video, it's adding a royalty-free sound track, and syncing your images to it, as well, so they change in sync with the music. In just a bit, your video is ready to preview—tap on it to see and hear it. The three icons at the bottom of the screen are for editing your video. If you don't like the sound track it picked, tap on the music notes icon, and then tap on Replace Soundtrack to choose a different sound track from its built-in library. If you think the sound track you chose is too fast (or too slow), tap on the metronome icon (the center icon), and then tap-and-drag the Pace slider to the left to make it slower or the right to make it faster. To change the order of the images, tap on the third icon, then tap-and-and drag them into the order you'd like in the Sequence screen, and then tap Done in the top-right corner. Now, tap the play icon in the center of your video to see the edited video. When you're happy with it, tap on the Share icon in the top-right corner (the one with the arrow pointing up) and choose Save to Camera Roll. Back in Lightroom Mobile, tap on Camera Roll at the bottom of your Collections view and find your video to import it. (*Note:* If you don't see your video, tap on the three dots in the top right of the Camera Roll screen, and then tap on Videos so it recognizes those for importing.)

Why Download the High-Resolution Version

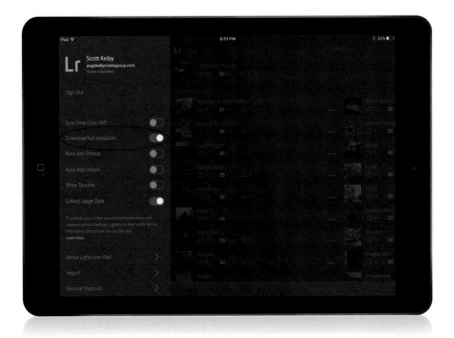

If you're shooting in RAW mode on your DSLR or your mirrorless camera, and importing a RAW photo directly from your camera's memory card straight into Lightroom Mobile on your phone or tablet (see page 71 for more on working with RAW images), of course, the RAW image gets synced back to Lightroom on your desktop, once it's in a collection. However, if you imported the RAW photo onto your phone, it won't send it over to your tablet—it will send a smart preview, instead (that is rendered from the RAW image). That is, unless you tap on the LR icon in the top-left corner of Collections view and, when the Sidebar pops out, tap on Download Full Resolution to turn it on. (*Note:* This feature is currently only available for iOS.) Now, it will send the full RAW image over to your other mobile device, as well. By the way, once you're done editing the RAW photo you imported into Lightroom Mobile, and the RAW original is synced back to Lightroom on your desktop, that RAW photo is still on your mobile phone (or tablet, depending on where you imported it) just taking up space. So, you might want to delete the RAW photo from your mobile device (for an iPhone or iPad, it will still be in your Photos app, as well) to free up space.

Clear Your Cache If You Run Out of Space

Lightroom Mobile stores a higher-resolution preview for all the images you've looked at recently in its cache file. That way, when you tap on thumbnails to view them larger in Loupe View, they appear instantly. As you might imagine, keeping a bunch of previews can eat up a lot of memory. If one day you find yourself in a situation where you're running out of space on your mobile device, you can free some up by clearing one of the two caches (either for an individual collection or for all of Lightroom in general, which will, of course, free up more space). To clear the cache for an individual collection, in Collections view, tap on the three dots to the right of the collection's name. Then, from the pop-up menu that appears, choose **Clear Cache** (as seen here), and you'll get a little pop-up dialog letting you know how much space you'll free up by purging these files. Tap Clear. If you want to clear the preview cache for Lightroom as a whole, in Collections view, tap on the LR icon in the top-left corner of the screen, then when the Sidebar pops out, go all the way to the bottom and tap on Clear Cache (as seen in the overlay). Now, when you tap on an image, you might see it pause for a moment as it pulls down the larger Loupe-view-sized preview—that's the trade-off, but at least you can see the larger-sized images.

Index

Index

Index

ANY MOMENT IS YOURS FOR THE TAKING.

This is a life choice. You choose to live creatively. You decide that any minute could be the moment that you capture and turn into something greater. Then you keep your camera at the ready and your designs in your head. Because if you only get one shot at something, you're going to take it for all it's worth. Fuel your creativity.

LEARN
LIVE

WITH SCOTT KELBY

IMPROVE YOUR CREATIVE
SKILLS IN JUST ONE DAY

kelby one live

COMING TO A CITY NEAR YOU | kelbyonelive.com